Smart Design

3 1 MAY 2024

RotoVision

A RotoVision Book
Published and Distributed
by RotoVision SA
Route Suisse 9
CH-1295 Mies
Switzerland

RotoVision SA
Sales and Production Office
Sheridan House
112–116a Western Road
Hove, East Sussex, BN3 1DD, UK
Telephone: +44 (0)1273 72 72 68
Facsimile: +44 (0)1273 72 72 69
E-mail: sales@rotovision.com

Website: www.rotovision.com

10 9 8 7 6 5 4 3 2

ISBN 2-88046-524-9

Book designed by IconBrandlab

Production and separations by
ProVision Pte. Ltd. in Singapore
Telephone: +65 334 7720
Facsimile: +65 334 7721

Printed and Bound in China by Midas Printing

Smart Design
The products of lateral thinking

Clive Grinyer

3

# Contents

# What makes a smart product?

In a technological world what man does with technology makes the difference. Smart design is the innovative solution that fulfils our needs, surprises us, and takes our lives in new directions. Making technology have value in our everyday lives is the job of today's designers. Whether a toaster, an aircraft seat, a mobile phone or an item of clothing, we can incorporate complex technology to deliver benefits that enhance our work, play, knowledge and learning.

This book is about products that do more than just work – they enhance and enable, surprise, delight and excite. They work, and even entertain, in ways greater than the sum of their parts. Many often contain technology in the form of electronics or new materials. But this technology has the intention of enhancing our needs and working within our terms.

Behind all of these products are people, some of them designers, who make the decisions on our behalf, connecting the far reaches of manufacturing, science and technology to our lives in ways that make sense.

The truth is we don't always want products, we want the results they bring. We don't want an iron; we want non-creased clothes. We want light, not a light, and we want to watch a film, not have a TV. We are forced to use products to achieve these tasks.

But we have to use objects that connect us to the services we want, and with those objects is a sense of wonder and pride. The design of products can exceed expectation and give joy, upon sight, upon touch or upon use. That delight is the product of design that can deliver what we need but also what we want, or did not even imagine we could have. The products around us may provide urgent medical help, or beautiful music, a good night's sleep or a conversation with our children when we are far away. Whatever it is they do, they can perform with care, thoughtfulness and intelligence. Smart products work for us.

Many products work and accomplish the job you expect them to with minimum fuss at appropriate cost and we live in passive tolerance of them. Your laptop computer may be a thin grey slab of memory, keyboard and screen. Your telephone may be a bone-shaped lump that you speak into. But there are other products that jump out at you to grab your attention and make you wonder why we put up with so much drabness. These products change the rules, provide more than you ever thought you needed, and make mundane tasks enjoyable. Such products give joy through knowing that it is possible to do things better, by consideration of our needs, wants and emotions, rather than simply our functions.

Smart products have some or all of a number of attributes; they address the obvious, moving laterally around an age-old problem, providing us with something we didn't have, changing the goalposts and providing us all with what was once a luxury. The collection of products in this book do all this and more; they please our emotions and raise our spirits through their aesthetic beauty, their sense of detail, their extraordinary efforts to perform, enhance and delight.

The idea
A great idea can be the root of the whole product. The company which produces the Titan Monotub is built around a single great idea, a washing machine that works for you, where the drum is the laundry basket and you can uniquely add clothes halfway through the wash.

Another British company, Psion, is built around transportable pocket-sized computing. It has, with time, moved from being the creator of just the products to the creator of software that combines mobile computing with mobile telecommunications.

But a great idea can be a variation on a proven theme. Audi has set out to redefine the car as a product – where you get just what you need and no more. Their great idea was to understand and focus on what a family would need in a vehicle and provide it with fastidiousness and attention to detail.

Ideas can change something that has been done so many times that no-one thought there was any other way. The Apple iBook is a laptop, with a screen, a keyboard, a processor and a hard drive. But it does not have latch or an 'on' button; it comes to life when you open it and sleeps when you close it. You hold it, hug it, and walk around with an object of great function and great beauty, which is as simple to use and as portable as a book.

## Technology

Technology is not just about electronics. New materials and processes allow us to have different and better things. But a smart product is not just about the technology, it is about much more. Over the last half century the world moved from one of mechanical functionality to one of technological achievement, where technology began to replace and assist in many aspects of life. Technology, however, was in the driving seat, and we were forced to work with technology that would not always work as we wished or expected. Despite years of complaint, video recorders still confuse and alienate people and technophobia is rife.

The speed of technological development is now so great that we can do almost anything we imagine and lots we haven't thought of yet. We can ask ourselves what we wish to do rather than what the technology might allow us to do. This means that it is our services, banks, broadcasters and communication providers who establish technology based on what we want to know and do. Designers, and therefore society, lead and control technology. The only shackle to our development is whether we are able to look forward rather than back and address the needs of the future rather than the present.

## Emotion

Designers have moved on from the Bauhaus creed of form following function to one where form follows emotion. And this is not about styling; emotion helps us understand the purpose of a product, reflecting our moods and giving us joy in an object every day we use it. It's important that a chair is relaxing, or a piece of machinery is safe and easy to understand, or a toy funny or a telephone comfortable. Emotion is as much a part of a design as where the buttons are.

Emotion is not something layered on by a stylist. In an aircraft seat it is as much part of its function that the traveller feel calm, relaxed and safe as it is fire resistant, ergonomic and accordant with safety regulations. Emotion is a key component of product design, but not one which designers are always conscious of. Emotion is about shape, colour, texture and operation and when all these things come together we recognise and appreciate it. Emotion is the most difficult function to achieve because it requires the co-ordination of all the 'soft' and 'hard' aspects of a product, from our tactile response to the physical to our cognitive understanding and ability to control and respond.

## Intuition

Smart products get under our skin. Designers know what we really need and want. You know a smart product when it works for you perfectly, when you reach for something and it's there, when behind a flap is the thing you didn't expect but wanted to see.

## Materials

Products need not be plastic or wood or metal. Computers need not be grey and opaque. Products can be allowed to wear out, like an ancient travel trunk, and take on new forms as you use them. What happens to your product at the end of its life is now important, and could affect how we feel about ownership and disposability, if throwing away means rejuvenation through recycling rather than disposal and waste. Sustainable processes will come to redefine how we view manufacturing and ownership of objects— we will have to give them back and trust they will make our next products.

Our preconception that products are about functionality and everything else is ephemeral has repressed their design, apart from car design, where style, aspiration and self promotion is recognised as the most important aspect of the vehicles we own. A Skoda does just the same job as a Mercedes.

So why isn't every product smart? They could be. From an electric plug to a stapler, from an armchair to a vacuum cleaner, there are countless opportunities in their design for excellence in function, emotion and usability. And the key to making all products smart is design. Design is both a team activity and an individual passion. At the centre is a designer, provoked, goaded and pushed, as well as supported, resourced and trusted, to interpret the world on our behalf and to create products that do their job better than any before them.

The purpose of this book is to look at examples of design excellence and understand the human thoughts and processes that have led to them. Design is not just a technical activity; it is a very human concern, applying understanding of human behaviour, emotions and desires to even the most basic object. It is also about the teams of people, not just designers, and the way people think together, to understand the basic ways we all live and how we might improve how we function.

9

Function
Although function can mean so many things, what the product does for you can be the only basis for the object at all. Doing the things you want and need is what counts. The car seat that folds flat, the mobile phone that gives you the sports scores and your bank balance, the aircraft seat that becomes a flat bed, the drill that becomes the ski polisher, these are functional ideas that we recognise a need for.

Function also means how well something achieves its goals, and in this a smart product should excell. It must do what you want and lots more.

Great products come from great designers working with people who are bothered to get it right. They believe that it is worth our while to go the extra mile, that it will make products of wonder and commercial success, that will hold a place in our memories and out survive the most vehement competition. For the world is not about price, but about value. The products in this book have the highest of values, no matter what their price. They have that highest value that comes from the trust, purpose, beauty and the magnificence of human endeavour which understands that even the simplest object can just be made, or made well, to satisfy the highest of goals in the simplest of objects, and make the vanity of technological achievement a humble servant of our real needs.

Comp

Products are designed to assist us and enable us to do more than we would once have imagined. They are tools for working, learning and relaxing, and become part of our everyday lives. Their design is about functionality, and then companionship. The products in this section have design integrated into their behaviour, for us to discover when we use them.

anion

# iBook
## Apple Computer
Design: Apple Industrial Design, USA
Team Leader: Jonathan Ive

## Sweet innovation

In less than 20 years the computer has gone from object of science fiction to social phenomenon. Originally a mathematical number cruncher, the computer is now an access point for global connection and communication and has moved from the work place into our leisure and education. But whether at work or in our homes, they often remain a pile of plastic beige boxes dumped on a desk and plugged together with cable spaghetti.

In 1998 Apple Computer took the computer away from the work place and created a product that both challenged the way computers look and sought to improve the way we view technology. The original iMac computer received global acclaim, transforming the design of the personal computer into a multicoloured fashion statement that made people who were previously alienated and confused by technology embrace computing and the Internet. The company then sought to translate these ideas into a portable format. 'We announced the iBook as soon as the iMac was launched,' says Jonathan Ive. The iBook was to be a portable laptop computer aimed at student and non-professional users. It was set to change the emphasis of the computer from a machine for business to a personal companion.

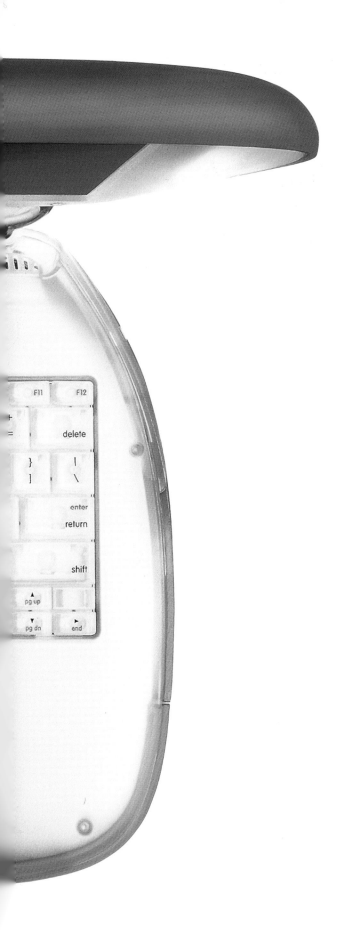

It is what the iBook does not have that sets it apart from its predecessors. The designers decided from the start that the iBook would have no latch, that it would simply open and close and turn on and off as a book. Not having a latch sounds simple but this required great effort in the mechanical design of the hinge and screen that would remain steady in use on a plane or a train, be easy to adjust, and clamp the product shut firmly and securely.

As in the iMac, nearly every established moulding practice was broken to create the deceptively simple form and function. The iBook required incredible detail design and investment into the complex tooling. The outer cover is designed to return over the front edge to create the latch that keeps the lid closed. A by-product of this is a soft, rounded edge that is comfortable for carrying. When the lid is up, the palm rests again on a soft, unbroken surface, unlike the more normal hard edge of conventional laptops.

For Ive it was just as important to consider how the iBook is seen when not being used. When the lid is closed Ive and his team saw opportunities to extend the character of the product. Ive wanted to address the sleep light, which when you wake in the night to see your sleeping computer blinking every few seconds, is attention grabbing, rather than reassuring. They wanted the sleep light to behave differently, to feel like it really was asleep. Their ideas proved too difficult to achieve through software, but the idea was so compelling that a separate piece of electronics was developed to achieve a 'sleep' effect. The result was a heartbeat effect as the LED slows down, gently brightening and dimming, as if breathing in sleep. When the product is activated, the rate speeds up and the iBook comes to life. Within a week of launching there were a number of websites devoted purely to the sleeping LED.

**The original bondi blue translucent casework was soon augmented by a range of five colours, which graced the billboards of the world like a brace of boiled sweets with the strapline 'Yum'. In fact, manufacturers of boiled sweets had been consulted to help achieve the transparent colours.**

Although the place in history will go to the original iMac, the iBook is the perfect exemplar of the philosophy of Apple Computer that earns them fanatical loyalty from their customers. The iBook, at first just a portable laptop computer, represents a new standard in the way we deliver and relate to technology. 'In designing the iBook I began to redefine what we mean by function. A product which has a power button has a pretty blinkered view of function.' For Ive the established ways of making products get in the way of what we really want. Why search for a power button, when what we want is for the product to be on? Power buttons are so familiar that we assume we have to have one. For Ive, the purpose of the designer is to challenge every assumption, and focus on the core need and how we would naturally carry out a task. At the core of the design of the iBook is the desire to give immediate access to technology and be as simple to use as a book.

## From beige to bondi

The Apple iBook represents one of the most thoughtful, radical and innovative designs yet produced. Its innovation is not in its physical difference, as in a Dyson vacuum cleaner for example, but how it redefines what a technology product can be. Its success is that it puts human needs in front of the technology and reminds us that technology is in our service rather than our master. It is the designers' sense of humane, personal and craftsman-like love of the object that delivers the technology and what we want to do with it that connects to us.

The lesser-noticed achievement of the iMac and iBook is the commitment to innovative engineering and manufacturing. The choice of material meant that investment in prototypes would be greater than normal and in understanding how translucent material would mould, Apple were able to push the boundaries of many aspects of manufacturing. The cost might have been many times greater than normal, but still small in comparison to advertising budgets. The result was unique and impossible to copy without cutting corners and looking cheap, which is what those who tried to follow have discovered.

When charging the batteries, the team developed a bezel around the power connector to change light as it charged. Ive wanted to make the product communicate from its heart, not conventionally by a flashing **LED** on the outside, but by changing the colour of the connection itself, from red to green when charged. '**We really wanted the plug itself to change colour, by firing light from the socket into the plug, but it was not bright enough in sunlight, so we used the outer ring of the socket,' says Ive.**

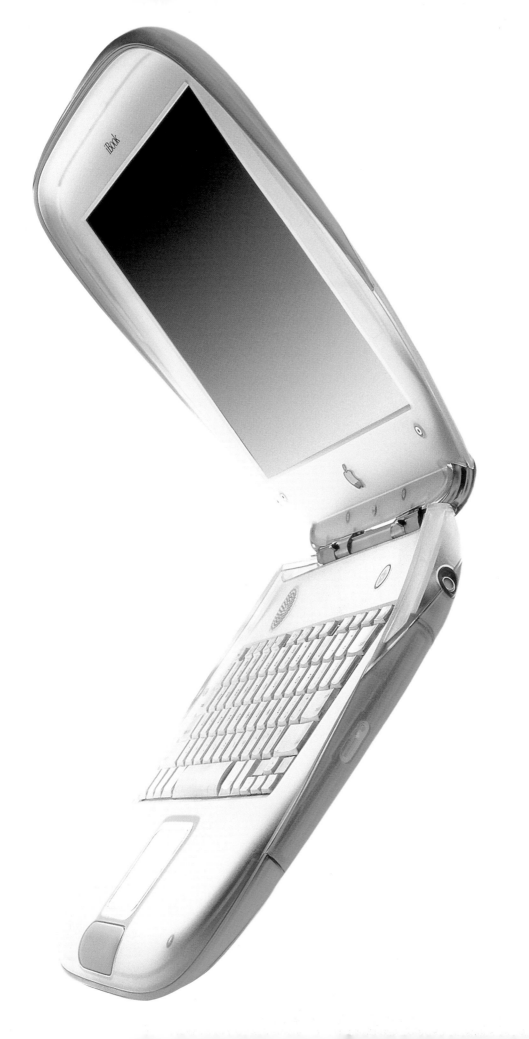

# WaveFinder Digital Audio Broadcasting Antenna

Psion InfoMedia
Product Design: IDEO
Team Leader: Tracey Currer

18

## Digital antenna for the PC

WaveFinder is a fully featured Digital Audio Broadcasting (DAB) radio receiver that runs on PCs. DAB is digital radio, which provides CD-quality audio with no interference. It is radio that comes through the air, but with a high graphic content and the ability to choose by style of music or subject content.

The technology to deliver DAB is expensive and comes in black boxes full of digital processing to turn air-born digits into audio pleasure. The WaveFinder is not a black box. It is a shimmering translucent spear that glows and flashes as it surfs the digital airwaves, and it then uses the digital processing power of your PC to create a low-cost, highly user-friendly DAB receiver.

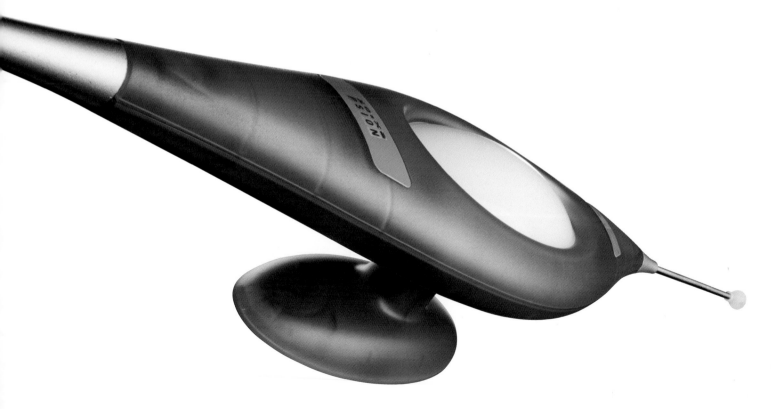

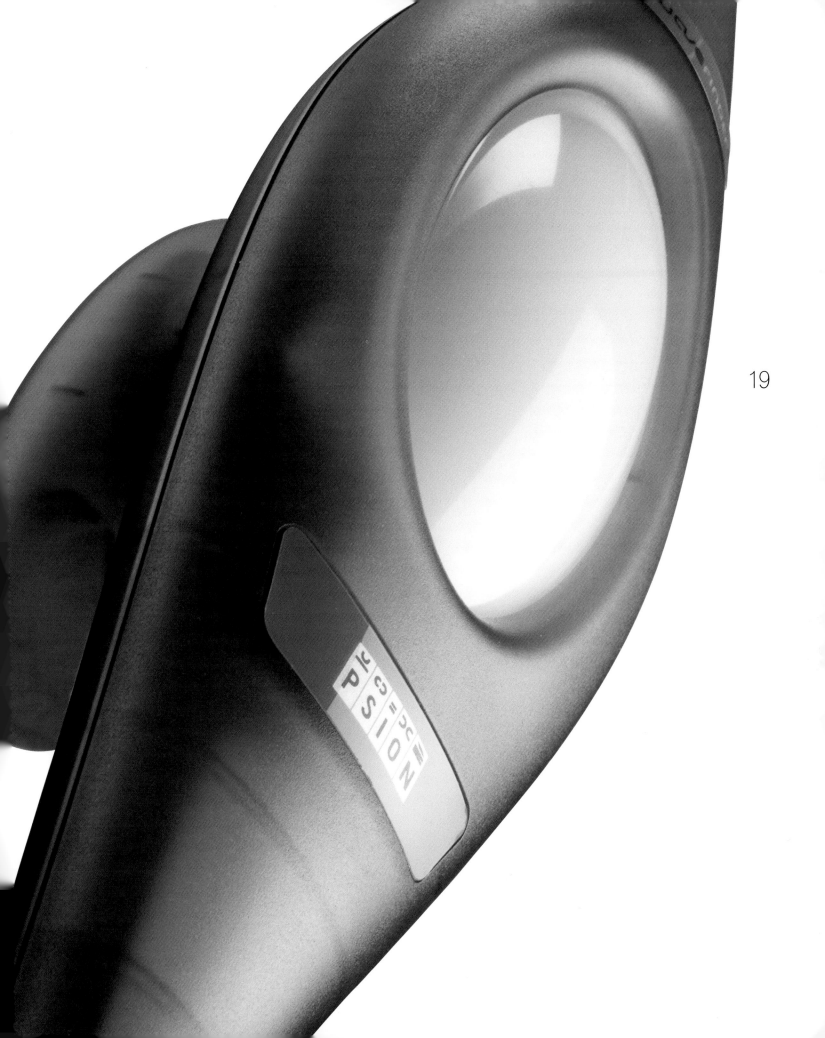

19

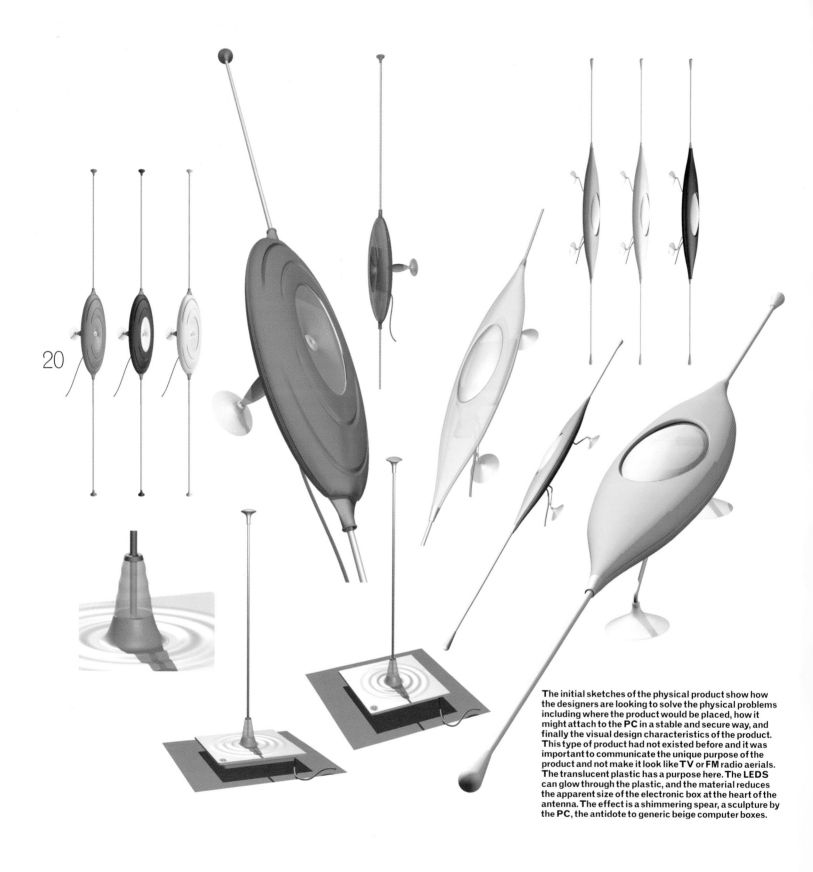

20

The initial sketches of the physical product show how the designers are looking to solve the physical problems including where the product would be placed, how it might attach to the **PC** in a stable and secure way, and finally the visual design characteristics of the product. This type of product had not existed before and it was important to communicate the unique purpose of the product and not make it look like **TV** or **FM** radio aerials. The translucent plastic has a purpose here. The **LEDS** can glow through the plastic, and the material reduces the apparent size of the electronic box at the heart of the antenna. The effect is a shimmering spear, a sculpture by the **PC**, the antidote to generic beige computer boxes.

In 1999 Psion, the company famous for their small keyboard organiser that invented the term PalmTop, set up a company to investigate potential new businesses around emerging technologies and social trends. Technologies around digital audio, including DAB and MP3, where audio files are downloaded from the Internet, have led to a huge change in the way music is bought or shared. An example is the case of Napster, an Internet site where music was 'swapped' without payment to the recording artists until the US courts forced them to change.

The WaveFinder is a great example of thinking 'out of the box', creating a half-physical, half-virtual solution. WaveFinder is an antenna and interface that allows you quickly to identify the stations available; it also chooses and saves your favourites, records transmissions on your hard disk and records programmes at any time in the future.

The design team at IDEO was led by Tracey Currer, who describes how the physical object and the user-interface concepts were developed together 'to create a holistic feel across all aspects of the product'. WaveFinder consists of a metal antenna and electronics, which locate and amplify the digital signal before sending them to the PC for conversion to audio and graphics. The designers created a flowing spear shape and aimed to make the product 'live' by using light to show when the antenna was operating. The idea of a glowing heart inside the translucent plastic was explored. The final product uses an LED ring which flashes while stations are searched.

## Innovation culture

Great design needs some things to happen. It needs champions, people at the top and all other layers of an organisation, who understand and believe that design and innovation is at the heart of their competitive advantage. Psion obviously have those champions, and they have the culture. Culture is the way people behave in meetings, the imagination and empowerment to search for excellence in their ideas and the partners they choose to help them. They also have focus – finding good ideas that connect technology to people in exciting, easy-to-use and affordable ways.

Innovation and design work with each other. Design can challenge your view of the world and look for different solutions. Innovation needs design to connect to people, to draw out and exploit the best of an idea, and constantly check that the idea fits the customer, not the other way round.

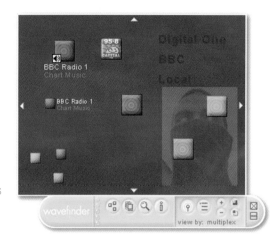

21

**The 'control egg' handles basic WaveFinder functions. From the control egg the user can open the 'map' which shows clusters of radio service icons that can be organised by multiplex or content. Users can personalise the map view by creating clusters of their own. When a user selects a radio service from the map, a 'data box' appears. The 'data box' allows you appropriate choices according to the audio, text or images being broadcast.**

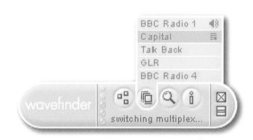

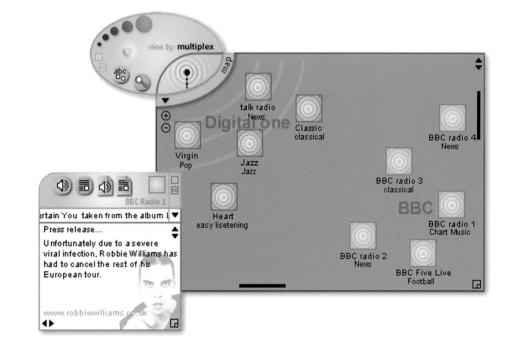

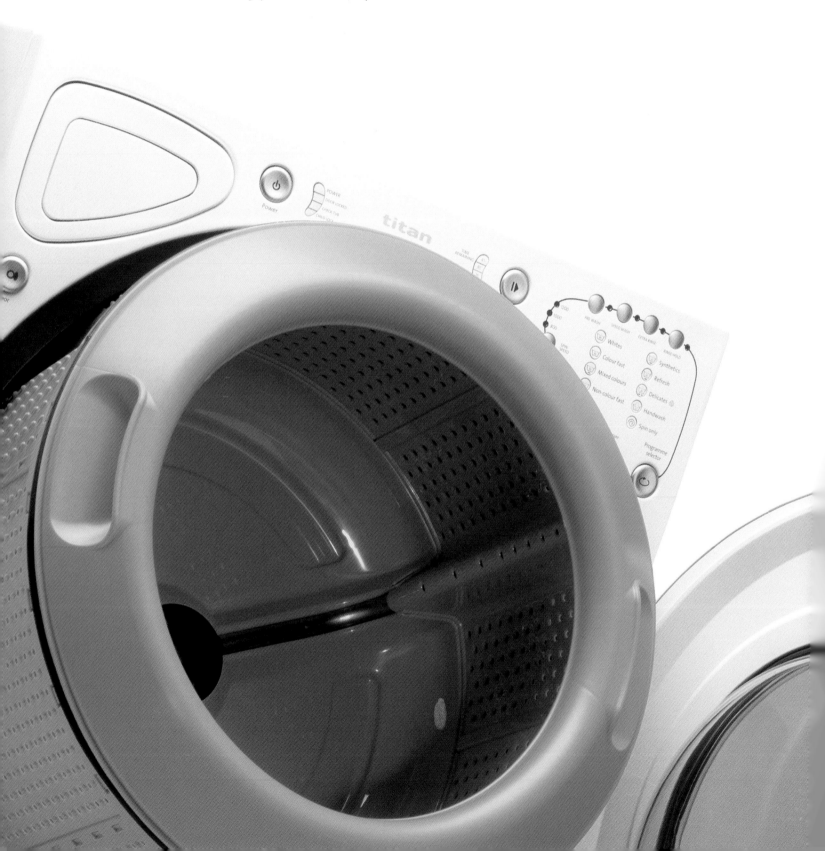

Titan Washing Machine
Monotub Industries
Invention: Martin Myerscough
Design: TKO Design
Prototype Development: Cock and Hen

# Invention and innovation;
# blood, sweat and clean clothes

'Design is about frustration,' says Martin Myerscough, the inventor of the Titan washing machine. His frustration was with washing machines that haven't changed for 30 years. 'Washing machines have been through great innovation, from the single to the twin tub to the current front loader but then they stopped.' A chance conversation with a washing machine repair man in 1993 led to Myerscough developing a radically new type of washing machine, and a whole new company behind it. Design consultancy TKO worked with Monotub, the company set up by Myerscough to create the machine, and Cock and Hen, a prototype engineering group, built the first test prototypes.

The washing machine represents a radical design shift. With the intention of giving the product the familiarity of other appliances so as not to alienate the consumer, the Titan was designed to fit into the same hole in the kitchen as any other, is painted white and has a door on the front with controls above it. But apart from the obviously larger door opening, it's hard to see what's so different about Titan. Open that door and you find a revolutionary product with engineering and design solving fundamental problems around the whole process of washing clothes.

titan

Power

Door

Start/Pause

Whites

Colour fast

Mixed colours

Non-colour fast

Synthetics

Refresh

Delicates

Handwash

Spin only

Programme
selector

Titan first existed as an engineering 'lash up', a collection of existing components and purpose-built prototype parts to show the basic engineering principles behind the concept. Proving that it was possible to use such a large drum at an angle, and distribute the water in the right way, was not enough to make the product real. To get investment and find retailers, the machine had to look the real thing – it had to be designed. 'We wanted to get a real response, and what we got was the "wow" factor,' says Myerscough. 'If we had not got that reaction, we would have stopped, but when we researched with users the Titan mock-up, designed and engineered to behave as the final product, we got a big reaction.'

TKO's team, headed by Andy Davey, included female designers with expertise in product design, graphics and marketing, to ensure that a strong, user-based approach was always maintained. 'With a number of important product innovations in place, it was essential that the designed product communicated these user-benefits in a clear and appropriate way,' says Andy Davey.

TKO had a strong sense of responsibility regarding Titan's image – a new product by an unknown company. They had to look at both the product and the brand from a consumer's viewpoint and consider all the 'softer' cultural elements. 'The design of the Titan isn't about novelty. The product has to be familiar enough to be instantly recognised as a washing machine: we communicated its innovative benefits in a form which felt comfortable to consumers.'

**Titan has a single innovation at its heart, which sets off a chain reaction of further benefits and innovations. A huge recycled plastic drum, which is removable for loading and collecting washing, takes up to 7kg of washing (compared to 4kg for conventional machines). To make it easier to load, the drum is set back at an angle. To make sure all the washing gets wet requires a sprinkler system where the water is pumped up through the centre of the drum and out from the door, so the machine can be stopped at any point in its cleaning cycle, to add or remove items to the wash. The result is a radical, 'sustainable' product with appropriate style, convenience and ease of use.**

**The visual design of the machine is the elegant result of the physical and user requirements. The drum, which serves as a laundry basket which you place directly into the machine, goes right to the edge of the machine, as the water is pumped not from the side but through the centre of the drum. This sets the enormous door size, giving wide access to the machine if used conventionally and plenty of room to get the drum in and out.**

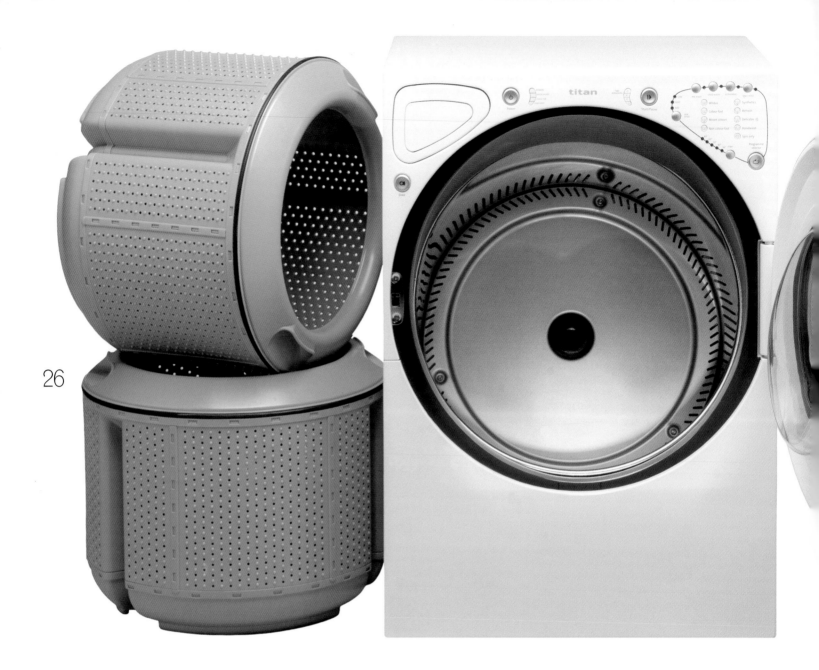

Despite its conventional appearance, the control panel is a radical departure in its simplicity. No complicated programme combinations here, just an intuitive set of push button commands. Press the temp button and the lights tell you 30, 40...up to 90 °C. Choices are laid out logically and in order of use. Clean graphics inform and advise, the physical shape of the buttons are soft and comfortable to press. The controls have the feel of a video remote control rather than the twist and click of conventional washing machines.

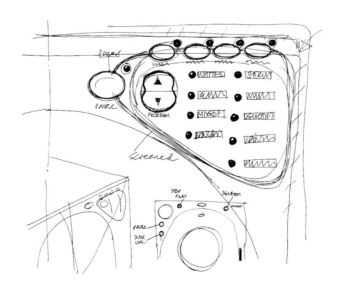

With the benefits of the product proven by research, and attractive, easy-to-use design at its heart, the business case for Monotub was strong. A private investor was found to fund the £1 million development and marketing costs. Even more importantly, a retailer was found, who was so smitten with the product they signed up for an exclusive contract on the spot. With this in place, the company was floated on the Alternative Investment Market (AIM) in London, a move which allowed backing for the tooling and manufacturing to be in place for the launch.

Titan is a story of design, innovation, and investment combining to make a completely new offering in an age-old market that thought innovation had no place. Titan's story proves a lot of people wrong and shows you can redesign and reinvent just about anything.

Challenging the orthodox

Why do things stay as they are for so long, especially when we all know they don't work particularly well? It is too easy to think that the same problems are so ingrained there is no possibility of improving them.

But, as Martin Myerscough points out, 'It's much easier to do these things on your own. Established companies have so much invested, it's hard for them to change. The companies I admire most are like IBM, who realised in the 1980s that their business, mainframe computers, was going to be replaced by individual PCs, so they switched completely.'

Titan is a total innovation, a company where none existed before, with engineering and tooling investment in a brand new product, not a virtual business promise but a hard fought physical reality of a product. What Titan is built on is the certainty of a better solution from consideration of an unsolved set of problems and a design that combines innovative thinking, elegant and functional design and manufacturing.

Titan is not just an innovation or invention. It is not just a heroic story of individual purpose and stamina. It is a combination of intuition, engineering and investment implemented through a design unselfconsciously fit to purpose, with care and attention to the detail. It is innovation as a combination of invention and design around a set of complaints that have been ignored by complacent and conservative manufacturers too frightened to really listen to their customers' experience.

27

# Quattro Power Tool
## Black & Decker

Design: Black & Decker In-house Team, UK
Project Designer: Lawrie Cunningham

## Innovation plus design
## equals commercial success

The market for home decorating and house maintenance in Europe and the US is a big one but market research told Black & Decker that not everyone wanted an arsenal of tools. Many people have little room for storage and were more interested in downsizing and simplifying, with a need for practical but easy-to-use products that were versatile and approachable. When Black & Decker developed a multipurpose sanding product with great commercial success, they realised that there was a real demand for multifunctional tools. The idea evolved of a single product that could carry out all of the main jobs for which power tools are used in the home.

Innovations have their 'Eureka' moments but they are also built on foundations of hard work, market research and faith in an idea. The Quattro is one of the most innovative products Black & Decker have produced, taking a simple idea of making one tool do four different jobs, and in the process creating a whole new type of product which had not existed before.

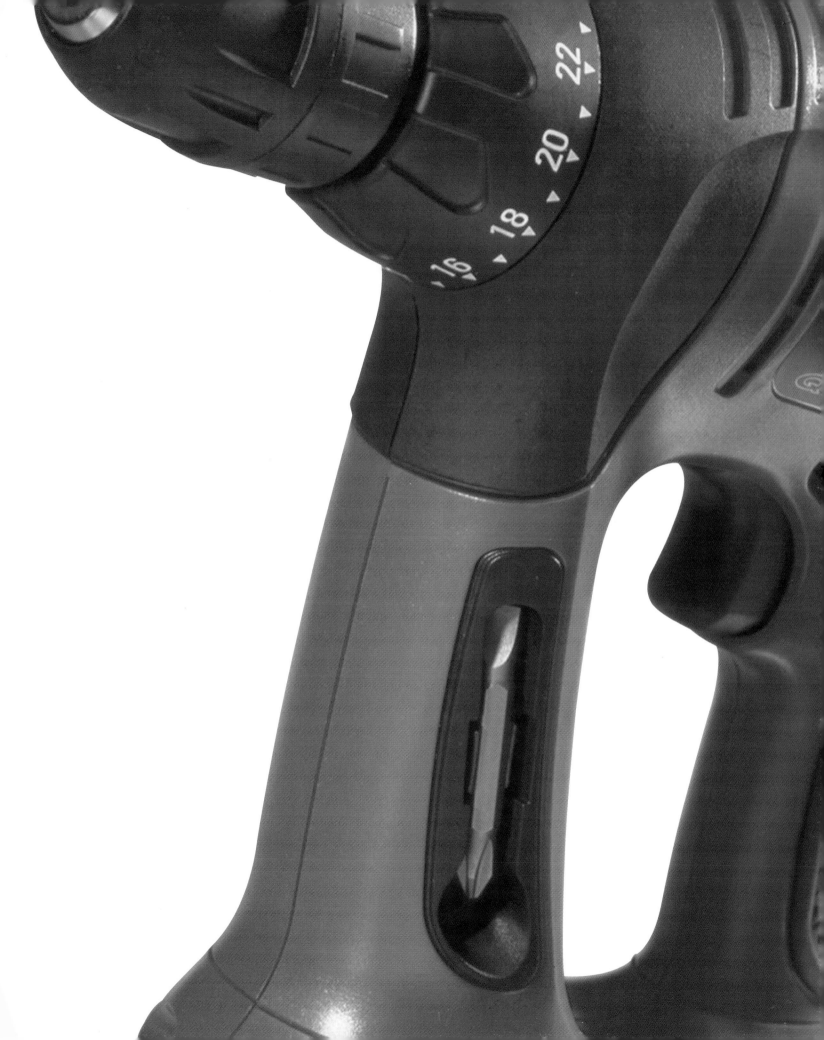

30

An informal group of designers, marketing executives and engineers, led by Head of Industrial Design Lawrie Cunningham, focused on the four main power tool applications: drilling, screwing, sawing and sanding, and how these could be combined into one simple product. It was not a new idea; Black & Decker had produced attachments for drills in the 1960s, which were very popular, but a modern solution would have to be easier, slicker and more intuitive for a wider range of consumers.

Having an idea and working out how to do it are one thing, getting the support and investment needed to make it happen is another. Lawrie Cunningham knew that an upcoming meeting of the global marketing team would be the chance to make the idea real and gain the support of marketing teams who could begin to make a case for the new product and convince the corporation of the merits of the project.

Using their standard rechargeable cordless power pack, the prototypes were shown to market research groups who gave the concept one of the best scores Black & Decker had ever registered. Their thorough responses about how they would use the product was valuable feedback, which was incorporated into the detailed design stage. With a strong champion in the European Marketing Vice President, the project was real.

The in-house team developed the shape alongside the detailed mechanical engineering. Ergonomics is not just about physical measurement of hands, it's about process and in this case is included in the optimum operation of each of the different tools; how they were changed and even how they are stored. The compact, self-standing shape is comfortable and curved and deliberately designed to reduce the macho component of power tools. The design aims to be gender neutral, without looking any less fit for purpose and robust for the job, and this reflects that users of power tools are as likely to be women as men.

Innovation cultures; design horizons
Innovation needs a big idea, but big ideas
come when the culture is right, allowing
people to think bigger than the immediate, and
when they have the support to nurture the idea
and show its full potential. The prize, as with
the Quattro, is a global first, a competitive
advantage that means your competitors
play catch up and, unless you then stop
being innovative, never fully catch up.

Black & Decker demonstrates a strategic
approach to innovation and design. This is not
just about keeping products looking the same,
though it is about taking the same care in
ergonomics and usability in every product
and exploring new materials and all aspects
of functionality. Design is not something
that happens at the end of the development
process, after the product has been engineered.
The designer's knowledge and understanding
of the customer led to the idea. Design was at
the start of the process, and was important in
configuring the idea to make sure it was right
for the customer and to communicate the
idea throughout the company.

**Visualisation of the concept and telling the story
is one of design's most powerful tools. A rapid
visualisation of the concept in sketches communicates
the idea and allows people to glimpse the potential.
The already overstretched Black & Decker team worked
with a local design consultancy to create sketches and
models, and to mock up prototypes from existing parts.
This allowed them to tell the full story of the user
benefits; how the product would look, the engineering
challenges to be solved, the likely manufacturing
investment and the marketing message.**

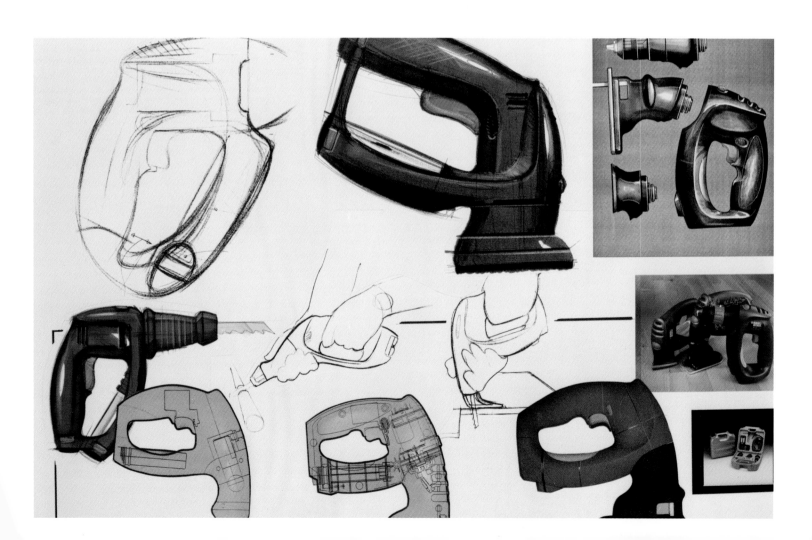

# HandiHaler
## Boehringer Ingelheim
Design Consultants: Kinneir Dufort
Designers: Ross Kinneir, Sean Devane

## Medical can be beautiful

Pollution, increased sensitivity to man-made materials and changes in our diet may all be the cause, but asthma is one of the western world's fastest growing illnesses. As the numbers of asthmatics have increased, new and improved drug companies have created treatments to treat and prevent attacks of asthma.

The HandiHaler is a dispenser of preventive drugs for asthmatics, to be used regularly throughout the day, wherever they may be, in private or in public. Drug company Boehringer Ingelheim developed their first inhaler in the 1980s. This used capsules of powder inhaled by the patient and had the advantage of not using aerosol propellants and not requiring that the patient press the aerosol at the same time as breathing in, something especially difficult for young children. Their inhaler was well engineered and worked in a completely satisfactory way, but it was big and ugly, and needed a separate carrier bag to keep it clean and dust free.

HandiHaler

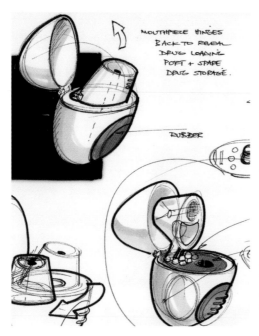

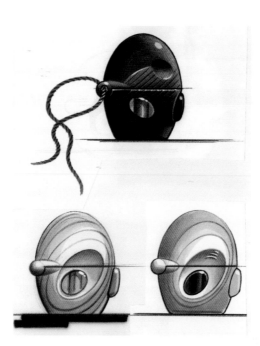

**The simplicity of the concept belies the complication of the mechanical design, which has to ensure ease of manufacture, as well as performance and usability. As the components fan out from the hinge, it is easy to understand how the capsules are changed, how the mechanism is cleaned, how the mouthpiece closes before inhaling and how the whole unit snaps shut. No instructions are needed; it is implicit in the form how the product moves and behaves, where it is held and the actions you make.**

Although the inhaler was not marketed directly to patients but rather the dispensing doctor, the marketing team at Boehringer Ingelheim objected to the unappealing and less than user-friendly product, and sought to create a design with much more consumer appeal through aesthetics and usability. They asked design consultants Kinnier Dufort to create a new design, which retained all the delivery performance but had an aesthetic appeal away from traditional medical products and towards consumer products.

As with so many pieces of good design, a simple idea solves many problems. Sean Devane from Kinneir Dufort describes their approach: 'We were really concerned not to affect the excellent performance, but having to put the product in a bag seemed wasteful and unnecessary. It was fundamental that our design had no loose parts which could be easily lost, and that the mouthpiece and mechanism be protected from dust. We realised that if we could reduce the size of the mechanism, we could encase both mechanism and mouthpiece in a plastic shell. This would seal it from dust, remove the need for a bag and make the inhaler more mobile so it could be carried in your pocket.'

**The pebble shape was established early on. It could fit in a pocket, be comfortable to hold, and would allow the components to fit inside. The case was designed to hinge open to reveal the mouthpiece, enable the user to add capsules and be easy to clean. The outside trigger punctures to allow the powder to spin out, and models helped make sure location and size suited the hands and fingers of the whole range of users.**

The design took two directions; establishing a shape concept that would be attractive, comfortable and functional, and a re-engineering of the mechanism to reduce every fraction of the volume as was possible. The mechanism was stripped down to the fundamentals of the vortex chamber, geometry and position to ensure delivery of the powder when the user took a deliberate breath inwards.

Suddenly the inhaler is a magical product; aesthetics, engineering, manufacturing and usability come together. The function of the product was seen as the delivery of a drug, but the function is also in use, and the ease and enjoyment of use. Function is not just a physical attribute, it is a powerful emotional component that might make the difference between consistent use and non-use of a drug treatment.

Design is not cosmetic: it's fundamental and functional
Manufacturers of medical products have a big responsibility. Their products are often the delivery points of healthcare, whether using technology to diagnose illness, monitoring our status during trauma, or delivering drug treatments. They have to create products that perform to the highest standards, with the utmost safety, and at the lowest cost, because whether healthcare is private or public, there's no room for unjustified luxury.

Historically design has been left out of medical products. There's no glamour contest on the store shelf to be won here; products are bought on the basis of performance and maintenance costs. But the experience of the patient is important and it doesn't take too much effort to realise that a calm and comfortable patient will recover faster than an anxious and scared one. Like glasses, hearing aids are a constantly worn and highly visible notifier of condition. Audio headphones are designed with style and comfort; why not hearing aids? Design has such a vital role in healthcare, but with the absence of direct consumer choice into the machinery and objects used, function is seen as an empirical hard solution.

**The designers came up with a number of ideas to make the product appeal to children. The products come in various colours and even painted faces.**

Avantis Iron
Tefal Calor (Group SEB)
Design Consultants: Seymour Powell
Designers: Dick Powell, Jim Dawton

## Designing the world's best-selling iron

None of us want to iron. The real solution to ironing is to create clothes that don't crease. But the iron remains with us, as a ubiquitous global symbol of the painful price for sartorial elegance.

Innovation or new technology has rarely changed the iconic silhouette of heated plate and handle of the humble iron, which remains much as it has been for two hundred years. It is not always possible or desirable to revolutionise something that is so clearly identifiable and works in an established and successful way, so the emphasis of design moves to evolutionary improvement, in materials and manufacturing and ease of use.

In products where performance is similar across a wide range of competitors, design, through looks, ease of use and the solving of simple functional requirements, becomes everything, the major component of differentiation. The Avantis iron is such a product, a truly global iron, with more than 1.7 million sold in countries around the world.

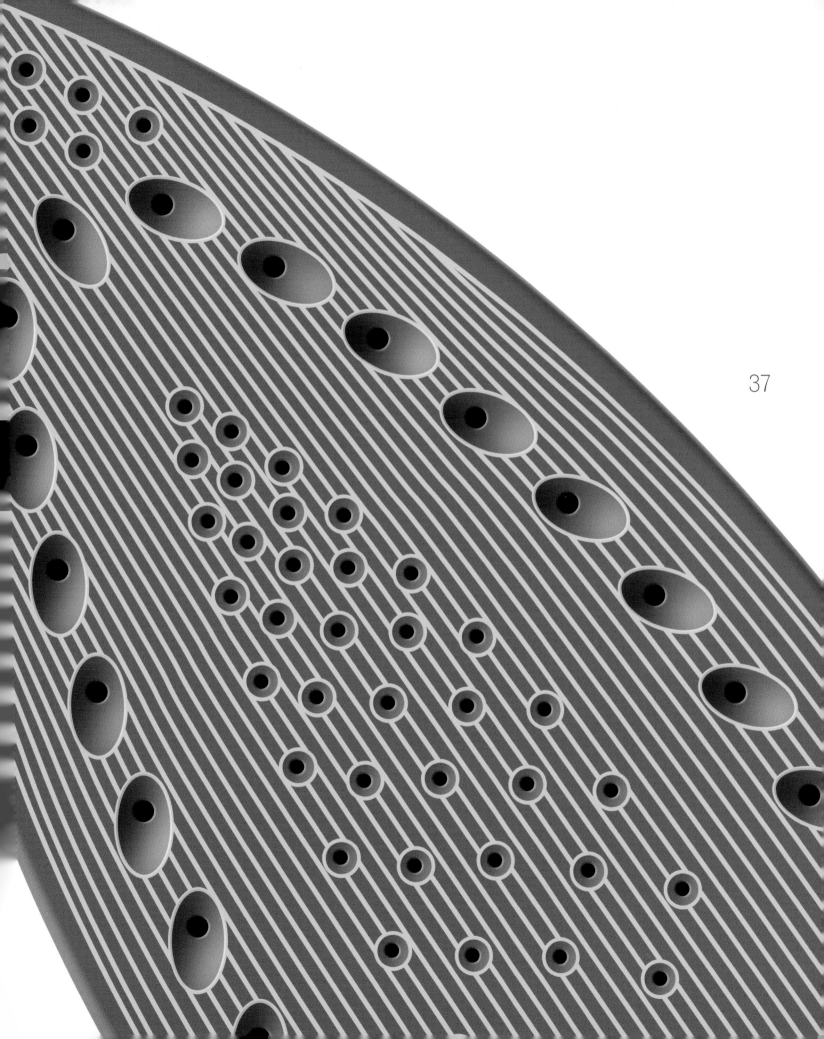

Avantis was designed as the replacement for the Ultra Glise (or Ultra Glide, depending where you are in the world), the best-selling iron in the world, manufactured by Group SEB, who are behind many famous brands including Rowenta, Tefal and Calor. The enormous size of the global market has led to intense competition. Huge investment in tooling and manufacturing is required to compete on price, and the design of irons has become crucial as products compete on the shelf of the store to catch our eye with style, ease-of-use and reliability.

SEB wanted to create a new design that was distinctive and which stood out, expressing improvements in performance under the skin. As well as being an excellent and attractive iron, it had to include elements that could be repeated on other products made by Tefal.

For the designers, led by Dick Powell and Jim Dawton of Seymour Powell, the design concepts were about silhouette, creating a distinctive form that was functional and visually unique. They described their concepts as 'Fast', 'Glide' and 'Comfort' to describe the emotions of the different shapes. 'The iron is a complex arrangement of over 100 parts combining electricity, heat, water, ergonomics and style,' says Dawton. 'But what was important to us was usability. We wanted the controls to be as big as possible, clear and easy to understand and in the right place.' The designers set about achieving this in a number of ways. Within the overall shape, the comfort of the handle and overall balance is paramount. The rear face is kept clean for stability when stood on its back, with a swivel ball keeping the cable out of the way.

The working end of an iron is the plate. Pointed at one end and flat at the other is the shape irons are and probably will be forever. But even here, within the detail of shape arrangement and even decoration, there is a host of subtle functional and emotional messages that enhance the performance of the iron. The heel of the plate is soft and shaped to prevent snags with pockets and buttons. Shaped holes guide the jets of steam between the plate and cloth to create a gliding motion. Lines printed on the plate aid it to glide, a feature so effective it has become the standard for all Tefal irons.

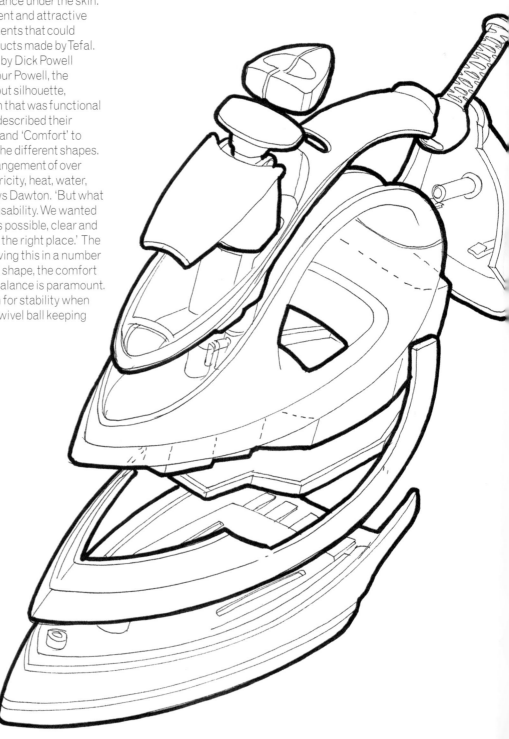

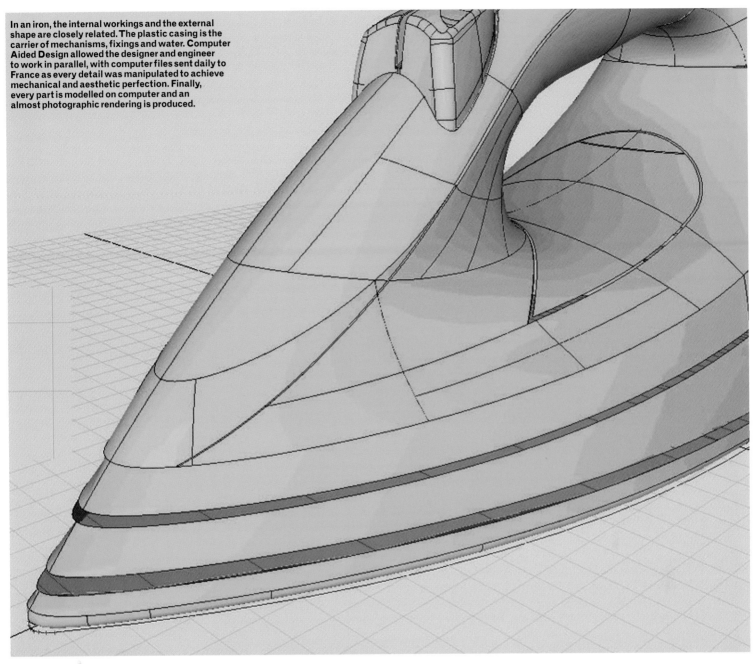

In an iron, the internal workings and the external shape are closely related. The plastic casing is the carrier of mechanisms, fixings and water. Computer Aided Design allowed the designer and engineer to work in parallel, with computer files sent daily to France as every detail was manipulated to achieve mechanical and aesthetic perfection. Finally, every part is modelled on computer and an almost photographic rendering is produced.

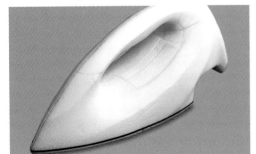

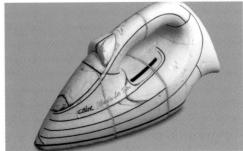

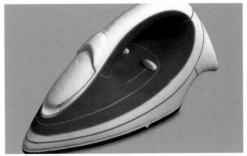

An iron is a very physical object and it was vital to develop foam models to understand the comfort and positions of controls. The shape can be better understood too, for as Dawton points out, 'an iron is a truly three-dimensional object, with function on every surface which is seen from all angles: in use, or when standing on its back.' Simple hand-made models show size and form. Computer-machined models check the design data, and hand-made appearance models show the final product, colours, finishes and graphics.

The Avantis is an example of a mass-consumer electronic product designed to stimulate the visual and emotional senses as well as achieving the essential functions required to do its job. From the care taken in designing the holes on the underside to controlling the gaps between components of different materials, the simplest of products is delivered with style and function.

40

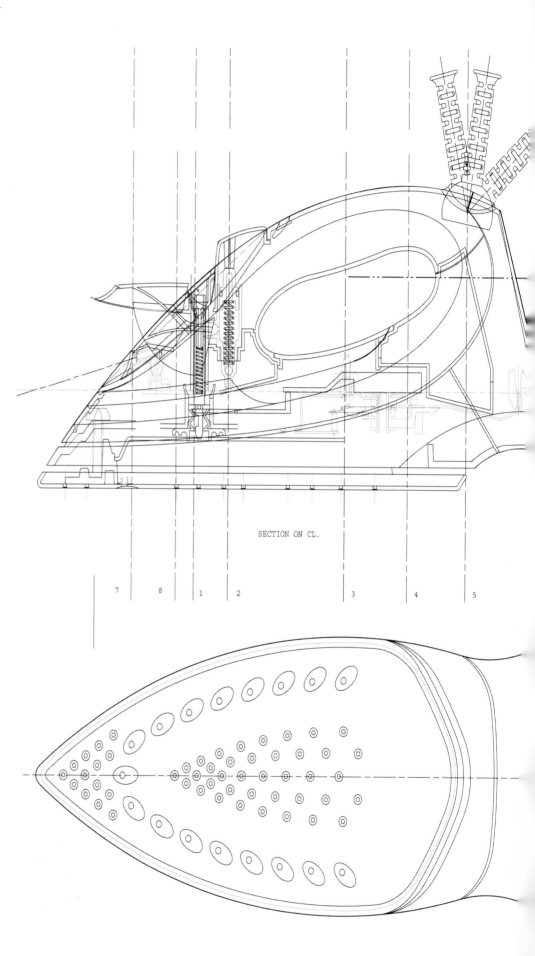

SECTION ON CL.

7    8    1    2      3    4    5

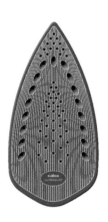

**Each concept is built around 'hard' engineering points. The building blocks of the iron are the sole plate, the water tank, the size and comfort of the handle, the mechanisms for filling and self-cleaning of the iron, and the cable. The concepts juggled these components to explore the possibilities of shape and the effects they produced. 'Fast' was so called as it created a sense of direction, movement and speed. The water tank was formed right around the front of the iron to create the illusion that the handle is open at the front, giving the perception of being lightweight and easy to grasp.**

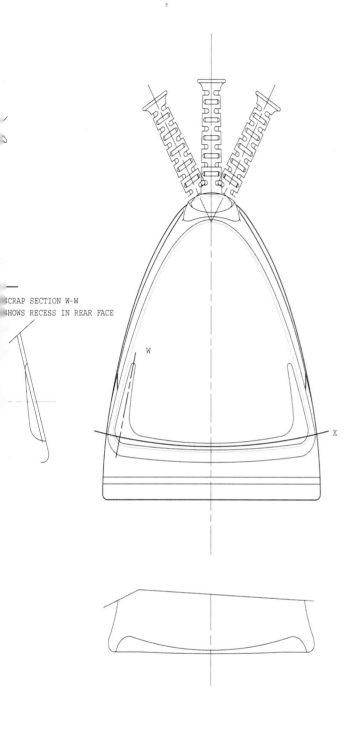

SCRAP SECTION W-W
SHOWS RECESS IN REAR FACE

Evolution, not revolution
Innovation is not always about invention, or new technology, or radical change and is not always visible on the surface. Innovation can be found in the evolutionary reappraisal and refinement of an established architecture.

An iron is a mundane domestic tool which we all use, and as such is as worthy of intelligent good design as the most complex piece of technology, in fact more so. It is the desire of designers to work with the mundane, the everyday, that provides beauty in the objects around us, that make design such an important part of culture, even our identity. Despite attempts at innovations in the whole process of ironing, the iron remains a utilitarian object hardly changed in its basic format since the introduction of the steam iron in the 1950s.

With so little to differentiate between one product and another, design may seem theatrical styling, a superficial approach with little functional concern. But to compete against fierce competition the Avantis has to work exceptionally well throughout the life of a product – from attraction to experience, from promise to performance. The design effort that goes into something as mundane as an iron is proportionally enormous, at the cutting-edge of marketing, design, materials, technology, engineering and mass-production.

41

**The water inlet to fill the tank was made much bigger by the designers. The original intention was for a hinged cover, but it was realised that, although easier to use, constant handling on display on the shop shelf could cause damage, so a simpler sliding cover less prone to mis-use was designed. Working closely with the engineers allowed them to move the heating controls to a more visible and comfortable position which could be easily pushed with the thumb.**

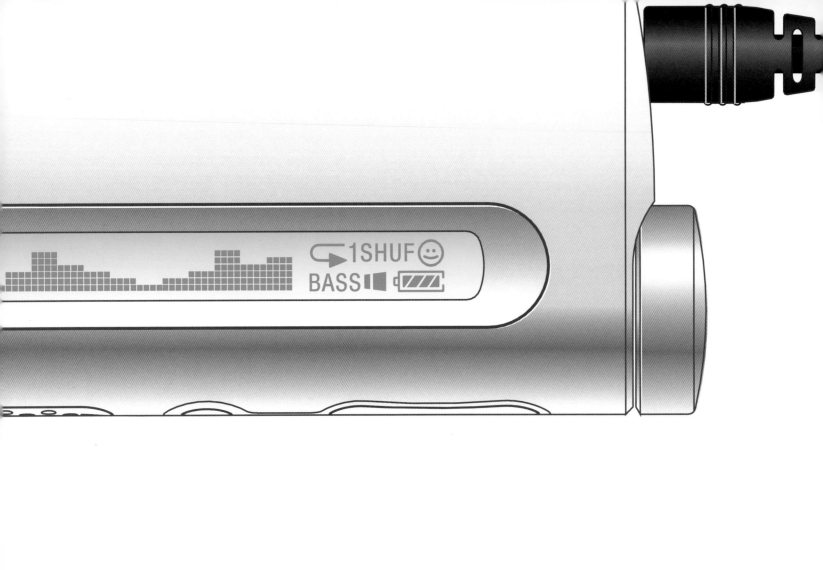

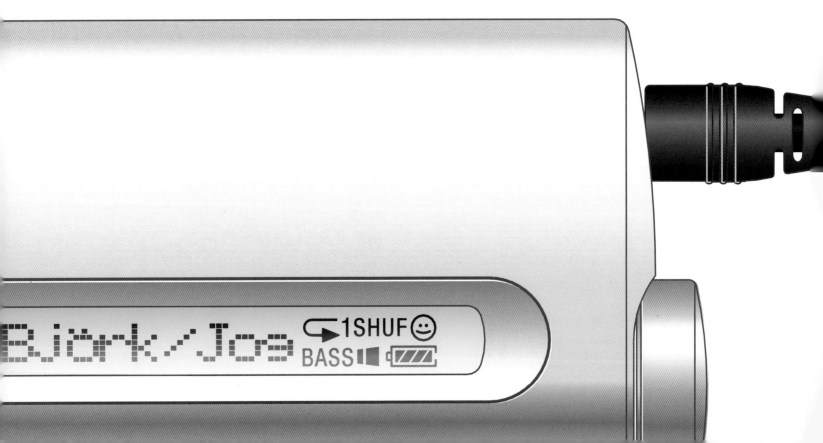

# NW-E3 Network Walkman
## Sony Corp
Design: Daisuke Ishii,
Takayuki Kobayashi

## The world's smallest Walkman

Designers have almost reached the point where technology
has shrunk to such a size that it is smaller than our hands can
hold and our fingers can operate. The size of the electronics,
screens and batteries is almost insignificant, a mere bulge in
our pockets. How can designers design products that are
desirable, meaningful and have value? How can they be easy
to use and have a tactile quality?

    The Sony Network Walkman shows us, maybe for the last
time, how we can still delight in the miniature and retain wonder
at the beauty of something so small. The first Walkman was
a miracle of miniaturisation that changed how we listened
to music. The latest generation uses not cassettes or CD but
MP3, a revolution in music source that has great impact on
both listeners and performers.

MP3 is solid state music, compressed digital media that allows the 64-megabyte memory in the NW-E3 to hold 120 minutes of music. Music can be recorded from CDs, through a PC, or downloaded from the Internet. With music so easily copied without reduction in quality, the ease with which music can be swapped, without payment to the original artist, has led to the rise of MP3 sites on the Internet. The popularity of sites like Napster has created great conflict with performing artists unhappy to lose financial return for their creative intellectual property.

Sony's designers set out to create something special. They knew that they could make the smallest and this gave them an opportunity to take the MP3 Walkman to a new level of elegance in design. Their concepts show how designers juggle with

the volume and format to create completely different types of objects. Sony made small 'soft' or foam models along the way to understand what the designs felt and looked like, as an object always looks larger on a flat page than it does in real life.

The unit is operated by a thumb-operated button at one end of the body that is pressed to play or pause, and rotated left or right for the next or previous track. This works better than the up, down, left or right buttons usually found on such products. By the final two drawings the designers had pushed the concepts to what they hoped were the optimum proportions, balancing depth and breadth to create a case of pure extruded metal with softly shaped controls and slots which reveal the display. The shear-sided appearance implies protection and precision, with an almost gun-like quality.

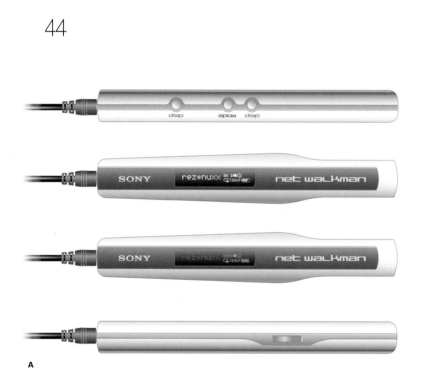

A

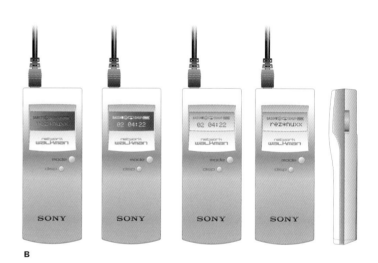

B

**Using simple 2D computer illustrations, the designers can show in full size what alternative component layouts and shapes will look like. Finishes, colours, and graphics are all shown in detail, as they combine together to create the final design. Concept A is a pen/stick shape with the headphone cable coming out of one end. Concept B is a much more conventional form reminiscent of a mobile phone, slim in the pocket and easy to hold but with no strong personality of its own.**

Sony: a logo or a philosophy?
Sony represents the Japanese success story, the logo that everyone in Europe and the US wants in their living room and in their pocket. Sony is, in fact, quite a small company in terms of Japan's economy, but its influence is huge, with so much of its hardware delivering the entertainment software in our lives.

The question is often asked, could you put the badge on any product and believe it to be a Sony? Is the power of the name so strong that we would believe the product to be better just because of its name?

Whatever the product there is a philosophy in every product from Sony that is similar. From more direct similarities, such as colour and rotating input devices, to the treatment of edges and lack of decoration, there is a sense of common purpose. Sony shows the power of brand not just through their logo but through design. It is a shared vision throughout the organisation understood implicitly by designer and customer alike. Sony stands for something and like it or not, it works, is recognisable and incredibly successful.

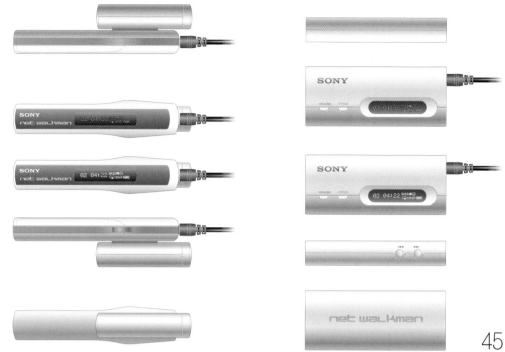

Concept C is similar to the pen of A but places the single AAA battery on the Walkman like a diverse oxygen cylinder. The intriguing shape emphasises the miniature electronics but might not be so comfortable in the pocket. Concepts D and E are the closest to the final design, with the 'extruded' form looking like machined metal rather than soft-moulded plastic. Various treatments around the button areas show where opportunities for character and ergonomics might lie. Even display colour is explored.

C

D

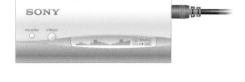

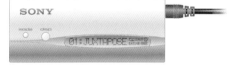

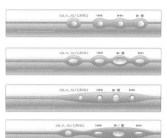

Concept E is wider but slimmer and smaller in height, looking not much more in size than a match box. The form of Concept D is developed further by the designers. The rotating operating button is now added, which creates a spare, almost featureless canister appearance. The display is set into a groove. This concept briefly explored a sliding mechanism to reach the battery, but this was changed to a simpler battery flap.

E

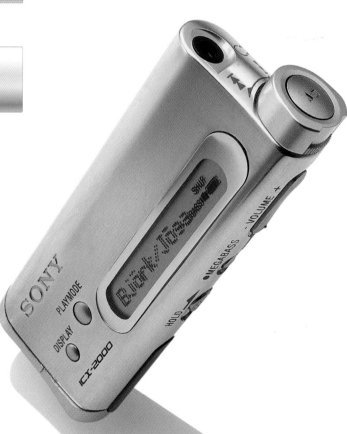

Elements of all the designs come out in the final product. A simpler, rounded display area emphasises the machined feel and a simple shape is added to the shuttle button to assist turning. The final design is pure, hewn from metal, almost like jewellery, an icon of technology and sophistication.

45

# Infinium Vacuum Cleaner
## Rowenta (Group SEB)
### Design: Seymour Powell
### Designers: Dick Powell, David Pearce

## Innovation and revolution;
## another bagless vacuum cleaner

The design of a vacuum cleaner reflects the culture it is used in. In Japan, vacuum cleaners are spindly and compact. In the US a vacuum cleaner is a power tool with a serious job to do and is wider and less attractive. In the UK the vacuum cleaner market was turned on its head by James Dyson who transferred technology from industrial air cleaners to create the bagless vacuum cleaner.

Rowenta are a world-famous brand from Germany with a strong tradition of design and manufacturing quality. When they wanted to re-invent the vacuum cleaner, they too identified the bag as a feature to be improved. Infinium is an innovative approach to the vacuum cleaner in a similar way to Dyson's products, but it does so in a very different style and with very different aims.

Using a technique developed by the military to keep the dust out of helicopter engines when operating in sand and dust storm conditions, Rowenta developed a system using a spinning dust chamber. Air is forced through the middle of a chamber, which spins the dust out over the edge and into a collecting tray, from where it can be emptied. But what interested Rowenta more was the affect on the shape and format of the vacuum cleaner which might radically transform the design and usability of the product.

Where many innovative products celebrate their departure from the norm, Seymour Powell saw it differently. 'We wanted this product to be part of the domestic landscape, not in conflict with its surroundings,' says Dick Powell.

Vacuum cleaners have two formats, upright and canister. Infinium takes a new direction and uses what Dick Powell calls 'vertical architecture'. Traditional canister-style cleaners are used horizontally and stored vertically, but the designers believed this a problem for manoeuverability and storage. Infinium is very compact with a small 'footprint', but is tall, bringing the controls within reach of the hand. Foot-operated controls require large surface area and robust engineering to survive normal domestic use. Infinium removes the need for materials and mechanisms, simplifying the mechanical design and decreasing the potential for damage in use.

Full-size foam models were used to check consumer reaction. The concept was popular, but moving from concept to manufacturing takes a lot of development. The mechanical design had to fit the concept, not the other way round, and the product designers and mechanical engineers worked closely together to make sure all aspects of the physical design were met without compromising the aesthetic, ergonomic and physical use of the design.

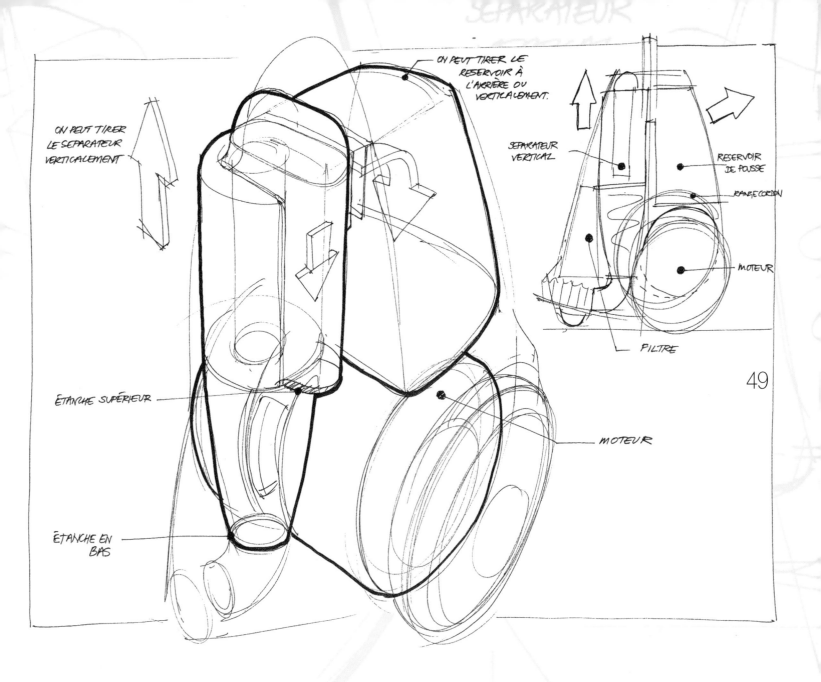

ON PEUT TIRER
LE SÉPARATEUR
VERTICALEMENT

ON PEUT TIRER LE
RESERVOIR À
L'ARRIÈRE OU
VERTICALEMENT.

SÉPARATEUR
VERTICAL

RESERVOIR
DE POUSSE

RANGE CORDON

MOTEUR

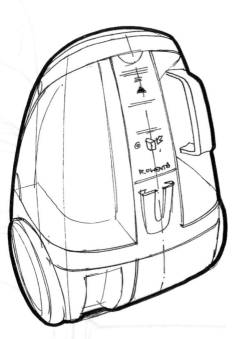

49

ÉTANCHE SUPÉRIEUR

PILTRE

MOTEUR

ÉTANCHE EN
BAS

From the first sketches the designers communicated
innovation, not on the outer surface, but in the change
in size and architecture the new mechanism offered. A
tiny window gives a glimpse of the inside, but otherwise
the technology is hidden — what is different about
Infinium is its height and shape.

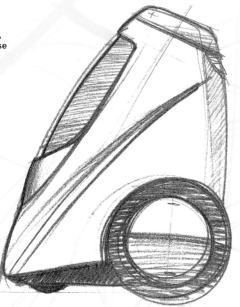

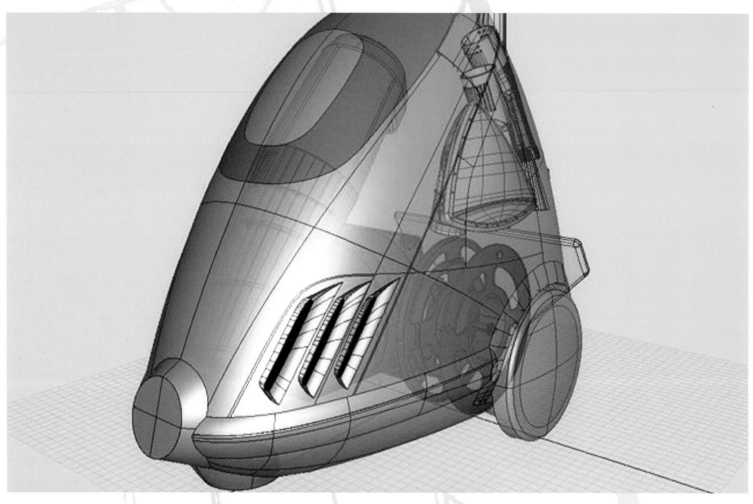

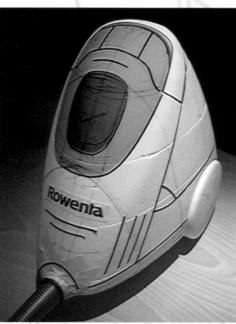

Understanding size and scale of detail requires rapid iterations and development of foam models, followed by a move to more rigid models and then a transparent translation to **CAD** and on to engineering development. **CAD** allows designers to respond quickly to changing engineering requirements and retain the spirit of the original intent, even when changes are significant. What is vital is the shared vision of the final product and a desire to get it right, from the big concept to the last detail.

Don't wait – innovate

The incredible success of Dyson has woken manufacturers to the potential rewards for innovation and new ideas in products and services. Rethinking how products that have remained the same for years can be radically improved leads to market success and competitive advantage. However, following other people's innovations too closely can be problematic and end in the courts if ideas are too similar in concept, as some competitors to Dyson have experienced.

Innovation is scary. To be innovative requires courage and bravery. There is comfort in gentle market evolution, with competitors gently jostling around feature levels and price. But this comfort is false, for innovative ideas give people the solutions they need where market research fails to find new ideas. The advantage to the innovator is rapid and long lasting.

The link between design and innovation is important. Design can lead to innovation, but also help deliver new ideas and ways of doing things. Designers tend to be naturally innovative, often more than their clients or colleagues feel comfortable with. But they also have the intuitive understanding of customers to help connect new ideas with real needs, and that creates a mechanism for evaluating the success and relevance of innovative ideas.

In the vacuum cleaner market, innovation changed fundamental attitudes and expectations in customers and manufacturers. Many different companies have come to realise that society is less content with established ways of doing things and demands innovative solutions to both existing and new aspects of life. The really scary thing is not being innovative.

51

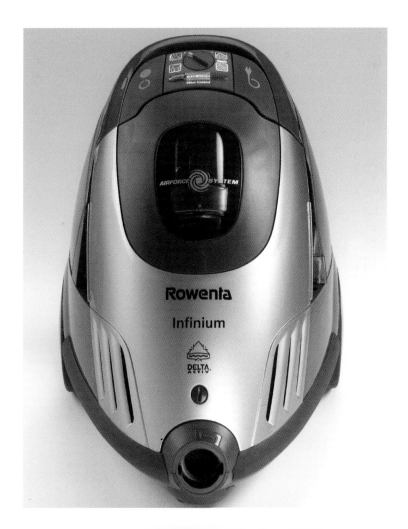

# TRAX 250 Watch
## Nike

Design: Rob Bruce,
Astro Studios, USA

## Tick Tock

Nike is one of the world's greatest brands. The ubiquitous tick graces every cap, sweatshirt, jacket and of course shoe. Nike started as a running shoe company but has become a global fashion brand. Despite the everyday nature of the clothing, at the heart of the Nike brand is the spirit of athletics. The huge payments made to the world's greatest athletes ensure that the link to sports is retained in our perception. It works, and despite a spate of negative publicity from poor conditions at its Asian factories, their products continue to command a price considerably higher than their competition and in great numbers.

As the brand exploded into general apparel, Nike looked at possible ventures into other equipment. They developed a range of sunglasses which could be worn comfortably whilst running. At the heart of athletic endeavour is the question of time: how fast, how long, how much better than last time? It was natural to move into watches. With only the beginning of an in-house team, Ray Riley, a product manager who had recently joined Nike from Apple Computer, went to a young design studio in Palo Alto called Astro. Astro had attitude. They wore baseball caps round the wrong way and had skateboards. They were building a reputation for fantastic creativity combined with an entrepreneurial sense. They were the sort of people Nike wanted to sell to.

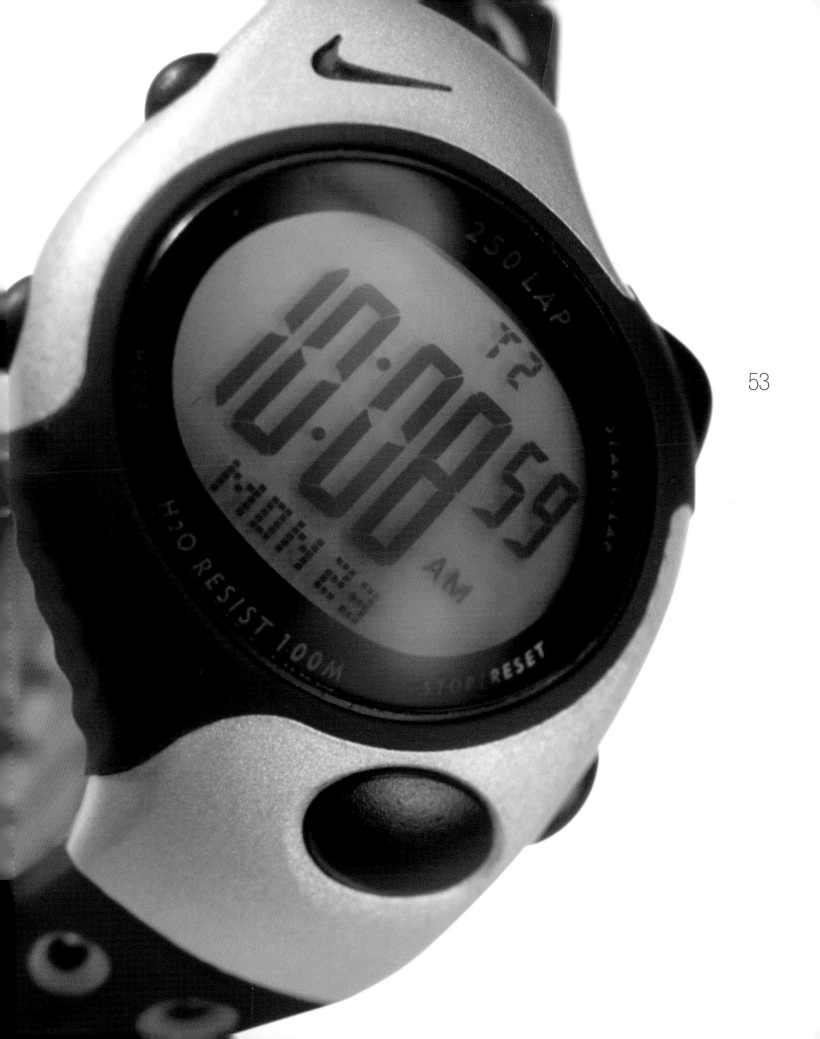

Rob Bruce at Astro firstly wanted to know what a running piece of sports timing could be like. He began to sketch all the possibilities that might generate the right combination of function and emotion. Nike doesn't make watches, so it joined forces with a world-famous Japanese company for the workings, known as the calibre. Rob worked with what he called this 'nugget' to build up his concepts but felt it wasn't enough – 'I wanted to break the rules, to push on further' – and this meant developing a completely new calibre.

Rob took himself off running to find out what the watch needed to achieve. His suggestions were radical and required time and money to succeed. First of all, the numbers had to be big. You need to see the numbers easily whilst running. Secondly, you needed to be able to find the stopwatch by feel, without moving your arm up and trying to find it. 'I needed blind navigation, using my fore finger and index finger to hit my split time.' Finally, the face needed to be rotated, so that it faced your face without having to turn your arm. Fifteen degrees placed it parallel to the eyes.

Nike knew this was the watch for them. They delayed launch and invested in developing a new calibre to achieve everything the design demanded. Rob went to work on developing the design as a single integrated plastic component using advanced co-moulding techniques, where different types of plastics are moulded over each other, but this was too risky for the manufacturer at that time. 'Designers think about the future; manufacturers think about today,' Rob laments. The watch had to be designed in a number of parts that came together.

The asymmetry created by angling the watch face was an opportunity to create a strikingly different watch that clearly communicated its purpose as a watch for athletic activity. Streamlined and limb hugging, every performance advantage was considered. Venting and cuts in the strap create a 'sweat management system'; softer materials are used in the strap to keep the watch comfortable.

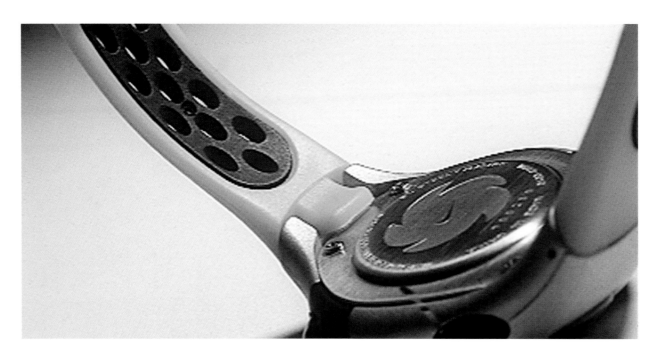

Rob Bruce wanted a flowing, streamlined design that created a feeling of integration with the body. Comfort is crucial when running or exercising, and the design had to look comfortable. Creating a single loop was not possible at first, so the body had to be connected to the strap. A variety of colours and finishes which would appeal to the desired market were finally considered.

1    2    3    4

1    2    3    4

The 'Ergo Pinch' (right) was an earlier version which was abandoned in favour of the angled face with large, tactile stop-watch buttons, easily operated blindly by the runner. The new concept, Iso (above), enabled the watch face to be angled towards the runner's face by 15 degrees. 'Apparently Luigi Collani did the same thing in the '60s,' says Rob, 'though I've yet to see it.'

The Nike TRAX 250 was an instant success, generating a whole new global market for purpose-designed sports watches. Within time it became imitated by every other watch manufacturer to become a new generic product. Nike responded with a new and improved watch in the TRAX 300. This time co-moulding was on the agenda and Rob Bruce could create a flowing and integrated design without joins from the strap to the watch as a single loop. Beneath the loop is rugged and hardwearing aluminium housing. TRAX 250 and 300 set the visual and material design language of Nike sports watches that they have developed into a wide range of watches for different uses, colours and styles.

For Rob Bruce the success of the watches is down to Nike's faith. 'They had the guts to go for a custom calibre, and even miss a sales season, because they believed it was important to get it right.' It was spirit of no compromise and a shared vision with their designers that doing the right thing would give them the competitive advantage. The rest is history.

## Business and design

There is a common perception that designers don't understand business; there is a difference in language that leads to misunderstanding and discomfort between business and design. But what designers do understand are the customers. In this case, the designers personified the customers and could tap into their emotional values and push the right buttons. Nike's design managers understood the values of their brand, and knew that the product had to have those right through. This was not a case of sticking a logo on a watch; this was changing the whole nature of watches, creating a paradigm shift, an innovative new direction where none had existed before.

Product design has to do more than just attract. A product is experienced over a long time, so the engineering, manufacturing and product design activities have to join together. In this case, they feed into each other: the development of new materials and moulding techniques enabled the design vision to come to fruition. The excellence of the watch calibre and the way it integrates with the body to give the correct tactile response are all crucial parts of the watch and must all work consistently over the life of the product.

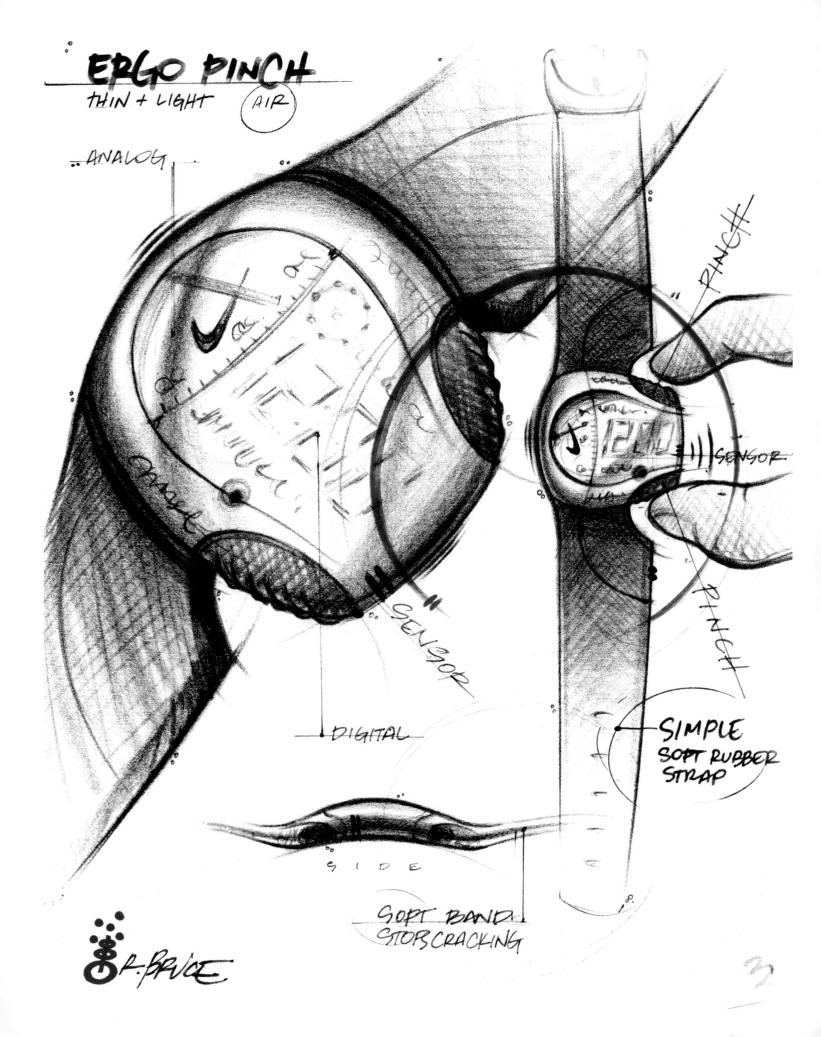

Products can be worn like jewellery enabling us to broadcast our style, knowledge, good taste or wealth. They have purpose and functionality but the reason we will always have certain products is that they allow us to say things we could never say ourselves.

# Vanity

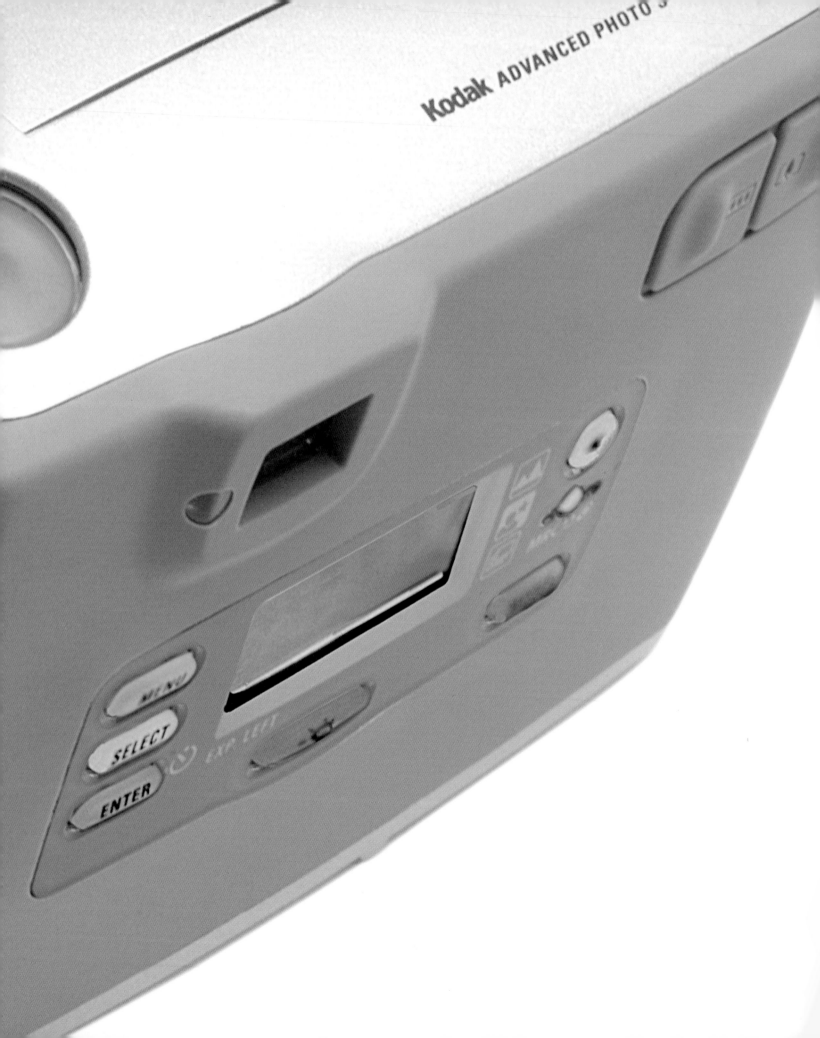

Kodak ADVANCED PHOTO S

MENU

SELECT

ENTER

EXP LEFT

# t700 APS Camera
## Kodak

Design: Geoff Hollington
In-house Design Manager: Frank Skop
Product Managers: Mike Barringer,
John Piper

## Discovering the DNA of a brand

The t700 camera was the first Kodak camera designed outside the US since Kenneth Grange created the Instamatic in the 1960s. Kodak, the name most synonymous with cameras and film, tended to look to its biggest markets in the US and Asia when designing cameras. Changes in camera technology, including Advanced Photo Standard and digital cameras, looked much the same as 35mm compact cameras. Kodak felt that the advantage of the new-format cameras could be developed in a fresh design direction, away from the traditional industry directions, to reflect the global nature of the brand and their products.

In a design-conscious world, Kodak wanted their cameras to increase in desirability, and to add tactile appeal and the more stylish elements seen in personalised mobile phones. They wanted to leap over the competition and change the rules, not just follow the accepted norm of ever smaller, metal-bodied cameras.

Kodak took the decision to partner with design sources around the world in conjunction with their corporate and development base in the US. They wanted to add different perspectives, to throw some new ingredients into the pot. Working in London with Kodak design managers John Piper and Mike Barringer, they chose to work with Geoff Hollington, a designer famous for his involvement with furniture company Herman Miller and Parker Pens. 'Geoff challenged our concept of what a camera could be,' says John Piper, 'but he knew about the DNA of Kodak – he understood the values we were striving for.'

Kodak and Hollington explored a number of themes. 'I wanted to revisit the glamour of Kodak's cameras,' says Hollington and the designs all have a strong sense of value and quality, as have Kodak cameras of the '50s and '60s. His aim also was to create more feminine appeal, as APS had been seen as a masculine, early adaptor format. But to compete with competition, the camera had to be compact and easy to use. Hollington started with the raw internal components and worked with a cross functional team of designers and engineers in Rochester, Connecticut, to create the optimal layout.

A strong feature of the camera is the 'flip-flash', initially developed to reduce the red-eye phenomenon where the flash and lens are too close together. This unique mechanism gives the camera a very physical change from 'sleep' mode to 'ready-to-shoot', the flap protecting the lens from outside elements when closed and pouncing into action for the shot.

The ruggedness and tactile quality of the camera is heightened by the soft rubber texture, complemented by the intricate chrome metal parts. Most striking is the colour; a soft muted green unseen in other products. Colour consultant Barron Gould was brought in to create the new colour, which he says, came from a glass bottle he found on a beach. They have now decided to use this colour on all new Kodak cameras. 'Five years ago Kodak cameras were still all black,' says John Piper. 'The colour is a real innovation, away from the technical appearance and from metal finishes traditional in the industry.'

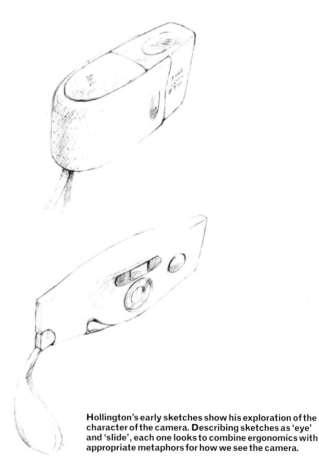

**Hollington's early sketches show his exploration of the character of the camera. Describing sketches as 'eye' and 'slide', each one looks to combine ergonomics with appropriate metaphors for how we see the camera.**

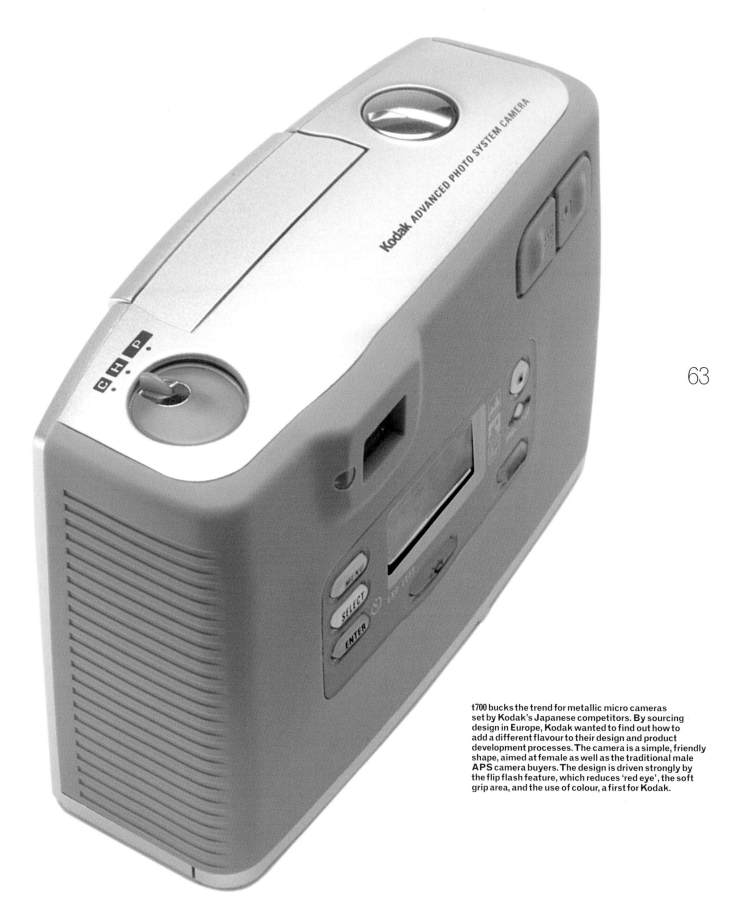

t700 bucks the trend for metallic micro cameras
set by **Kodak's Japanese competitors. By sourcing
design in Europe, Kodak** wanted to find out how to
add a different flavour to their design and product
development processes. The camera is a simple, friendly
shape, aimed at female as well as the traditional male
**APS** camera buyers. The design is driven strongly by
the flip flash feature, which reduces 'red eye', the soft
grip area, and the use of colour, a first for **Kodak.**

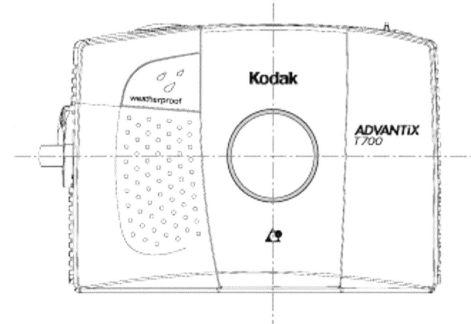

64

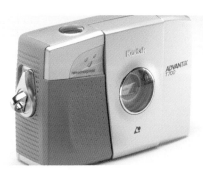

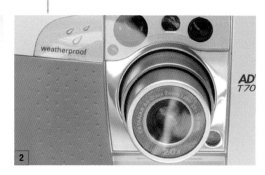

By incorporating the 'flip flash' concept the design was developed in two dimensions on **CAD**. The designer can work with real dimension and build in the detail and precision that will make the design a success. It is important to consider the exact radius, the dimensions of the side ribs, the shape of the lens and texture and graphics.

The outside design on **CAD** is developed until every detail is defined. The overall shape of the product is simple and pure, the quality and beauty comes from the precise positioning of buttons, the layout of the **LCD** display, and the combination of texture and material. Working with engineers and manufacturers until the last detail is agreed is very important and ensures that the final product is as good if not better than the original concept.

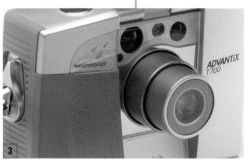

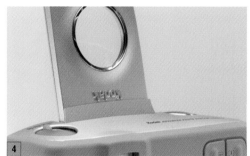

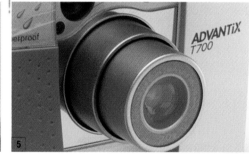

'The camera changed the organisation,' says Mike Barringer, 'especially the approach to colour.' The t700 has a progressive feel, and other products designed for different use and markets can build on that feel to be part of a cohesive range through the use of colour, texture and detail.

For Kodak the design has achieved a number of things. Kodak's drive to change and create new design excellence has changed the attitudes of the corporation, exposing it to a different creative culture and new working methods. It has led to a heightened sense of style and colour, and has enhanced public opinion about Kodak, with style magazines like *Stuff* raving about the new-found sense of design in Kodak's products.

For John Piper and Mike Barringer the t700 programme was an excellent example of a corporation, in-house and external designers, and OEM manufacturing coming together. It's a global product that will spawn a family of related products across the 35mm and digital formats as well as APS. It works as design, design strategy and process, and a large component of the strategy is colour, usually the last thing thought about by a product designer.

t700 is stylish, cute, easy to use, and soft to the touch. As we use it to record our memories and experiences, like the Brownie and the Instamatic it should make its own.

Character and Personality

Objects can be bland and grey, reflect their technology or power, or be invisible in use. The t700 tries to attract us through subtle association of materials and quality, a sense of style and desirability. These messages are communicated not through form, which is hardly present in the design, but surface, texture and colour. t700 shows how carefully the designers can put these aspects together with great subtlety and create a design of huge power and uniqueness.

Companies that don't just wait for the competitor's move, that don't wait to be told they are wrong, but actively look for the next challenging new direction, will find they lead and have assets beyond technology or manufacturing. Ultimately they change the culture by contributing to it, by bringing the new and not tolerating the stale.

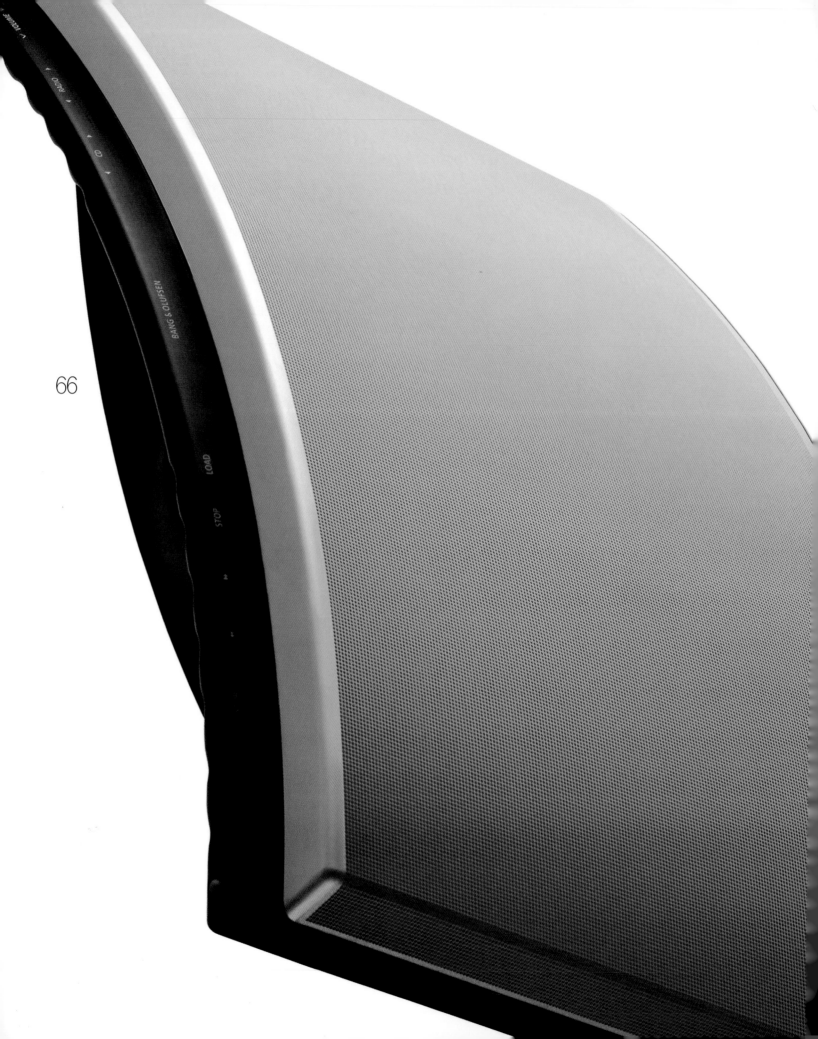

66

# BeoSound 1
## Bang & Olufsen
Design: David Lewis

## Sound and style

Music is an important part of people's lives. Around the home, in the background or at the centre of our attention, sound and music fill our living spaces. The way we listen to sound depends on what we want it for and where we are. Through headphones, on the move, in cars, in kitchens, as music or as sound track, music is delivered by a range of systems, from an MP3 player to an audiophile system.

Delivering sound of a high quality requires excellence in electronic, mechanical and acoustic design. At the highest end of the scale, quality is bought at the price of aesthetic design; equipment is designed to sound good first. In the US and Europe this usually means audio products come in black boxes, piled in a corner with a nest of cables out the back. Bang & Olufsen have never seen it this way. For more than 40 years this Danish company combined audio performance with the highest quality of aesthetic and usability design, materials and finishes in their equipment. Their products, modernistic, innovative, crisp and architectural in style and presence, take centre stage in the living and listening environment, not hidden away in the corner. For many, owning a Bang & Olufsen product is a mark of prestige, a label to show care and pride in design and inherent good taste.

BeoSound 1 is a single sound box with CD and radio. Designed by David Lewis, who first worked with Bang & Olufsen in the 1960s, it continues to be one of the strongest and most successful design relationships with a single company since Diet Rams with Braun. 'The principle goal was to create exceptional sound quality,' says Lewis. 'It was to be a transportable sound system, from room to room, but to achieve the quality needed required that it be a plug-in system, taking mains power rather than batteries.'

The size of the speaker enclosure is the main parameter. Conventional speakers need to be enclosed in a volume of air to work to their optimum, so BeoSound is fundamentally a large speaker box. It also had to be light, to make it truly portable, and combine the speaker box with electronics for CD, tuner and amplification.

David Lewis works in card to create shapes, which have a purity of curve and line, a strong component of the Band & Olufsen style. The 'double bow' shape of the BeoSound creates a pillow form, which is narrow and elegant at the edges and hides the width of the middle, providing the speaker with the required air volume and space to take the Compact Disc mechanism and electronics. The shape is formed from a pressed aluminium sheet perforated with tiny holes to let the sound out. This minimalist design is the antithesis of the bulging, chrome-plated, electronic audio monsters that most other manufacturers design.

As crucial as shape and attitude is material and colour. BeoSound colours the crisply formed aluminium in natural anodised finishes which, as they are not paints but a natural etching of the surface, bring out the

**The thin curved front hides the swelling of the back to take the CD mechanism and electronics. In an age where designers have exploited CAD tools to create fluid sculptural forms that we see in mobile phones or cars, the simple shape of BeoSound is pure and uncluttered. The graphics, too, are refined and unobtrusive.**

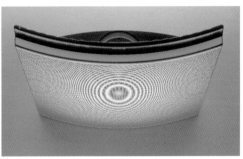

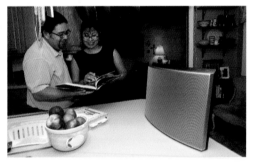

**The fine mesh of the speaker grill allows the light from the red LED display to show through. Rather than celebrate the technology, BeoSound cloaks it and just gives you what you need.**

subtle quality of the metal and also provide a range of colours. To achieve this Bang & Olufsen have invested in the resources and skills needed to create consistently high quality surface finishes in-house. This was not possible working with external suppliers, who could never afford the time and effort to perfect the techniques, which, once perfected, have become the company's most valuable and identifiable assets.

No logo required
Bang & Olufsen show how design can be at the very heart of a company, creating the values and philosophies that frame the technical and commercial activities of the company; a design philosophy which creates a sense of magic and beauty around objects that give us sound and vision, values which adapt to every technology or function. These values are communicated through shape, materials, colour, and performance and affect how we use them and where we place them in our homes. They are delivered through technical, engineering and manufacturing priorities that have the philosophy of excellence in the user experience at their heart. Therefore these values can be seen, touched and sensed and are so identifiable that we would not need to see the badge to know the company that produced the product.

**BeoSound 1** hides itself behind a simple, curved aluminium mesh. **The CD**s pop up and disappear, the display hides behind the mesh and the logo is subtle and refined. **Bang & Olufsen** don't need the logo; the materials, colours and purity of form tell us all we need to know.

# Aibo Robot Dog
## Sony Corp

Design: Entertainment
Robot Company, Sony Corp
Project Leader: Tadashi Otsuki

## Designing the world's first cyber pet

The Sony Robot Dog Aibo is one of the most remarkable products on the planet. Through exploring ideas around human social behaviour Sony's designers began to develop the idea of an electronic pet. The fad of Tamagochi, 'virtual' pets consisting of buttons and a simple LCD screen to communicate a set of behaviours, had established the basis for interactive electronic toys. By simply pressing the buttons the 'needs' of the pet such as feeding or playing, could be satisfied. Designers were fascinated by the emotional feedback possible from this little toy, and the search for interaction that began with Tamagochi, resulted in Aibo – only Aibo moves, crouches, walks, turns its head, sees and hears you.

Since the revolution of the Walkman, Sony has realised the social impact technology can have. More recently, the mobile phone and the modem have changed the way we communicate, as the Walkman changed the way we listen to music. As one of the most innovative companies in the world, Sony looks to invent the future rather than wait for it. So, in the mid 1990s, Sony began to invent a new type of entertainment, different to the static nature of conventional screen games delivered through games consoles such as the PlayStation. They looked to take play to a new dimension where technology could provoke real emotional responses.

The starting point for Aibo was in the design studio, where designers began to explore ideas around emotional themes of playfulness, friendliness and relaxation. Their ideas became focused into the concept of a small robotic animal that would combine robotic appearance with animal behaviour.

Building a series of prototypes helped the team study the movement and evaluate their success at retaining animalistic behaviour and motion. As the shape of Aibo began to appear from the mechanistic limbs and connections, the psychological characteristics began to be developed. If Aibo would be able to hear and see, the nature of its reaction would be generated through its software. The playful nature was important, so Aibo was programmed to respond to bright pink, a colour deemed so unfashionable that it would be very uncommon in a domestic environment. Aibo's favourite toy would be a pink ball, easily identified by its IR sensor that provided the ability to identify objects and respond accordingly.

The designer Hagime Sorayama and the team, led by Yuka Takeda of the Entertainment Robot Company of Sony, created an intricate piece of design that was expressive of the motion of the limbs and communicated technical sophistication. A single tinted visor creates Aibo's abstract face, which ingeniously gives both a robotic and an endearing appearance of huge eyes. Behind these are the sensor devices to hear, touch, and see through infra-red emitters and detectors and a camera chip similar to that used in a video camera. The ears were left to flop and move with the head. In the second generation of Aibo, the ERS 210, the ears stick up and have their own motion to express meaning, apparently in response to requests from owners. The new short tail sways from side to side as Aibo moves and has an LED to let you know that when it is 'asleep', it is still alive.

Sony searched for the most effective ways to express emotion and through studying real pets, aimed to be free of cold and inorganic robot imagery. Yet the design remains essentially robotic, the first of a cyber generation that will physically interact with us and create the illusion of behaviour characteristics. There is no attempt to create flesh or fur, though elements such as claws and the endearing floppy ears of the original ERS110 give anthropomorphic reality.

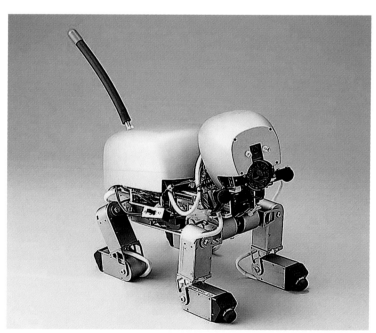
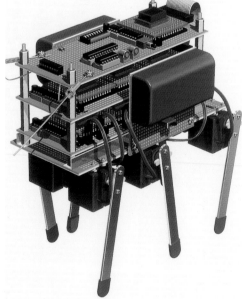

The first electro-mechanical prototype is visible as this circuit board on legs, but it soon became a moving gestural robot pet. The first shaping of Aibo, however, was more toy than sophisticated robot or cuddly pet. To create a sense of natural behaviour meant combining visual design, mechanics and software to mimic observed characteristics. Multi-directional bearings and motors were used to generate the types of movement associated with a young puppy: sitting, perched on its hind legs, moving its head and righting itself after falling over.

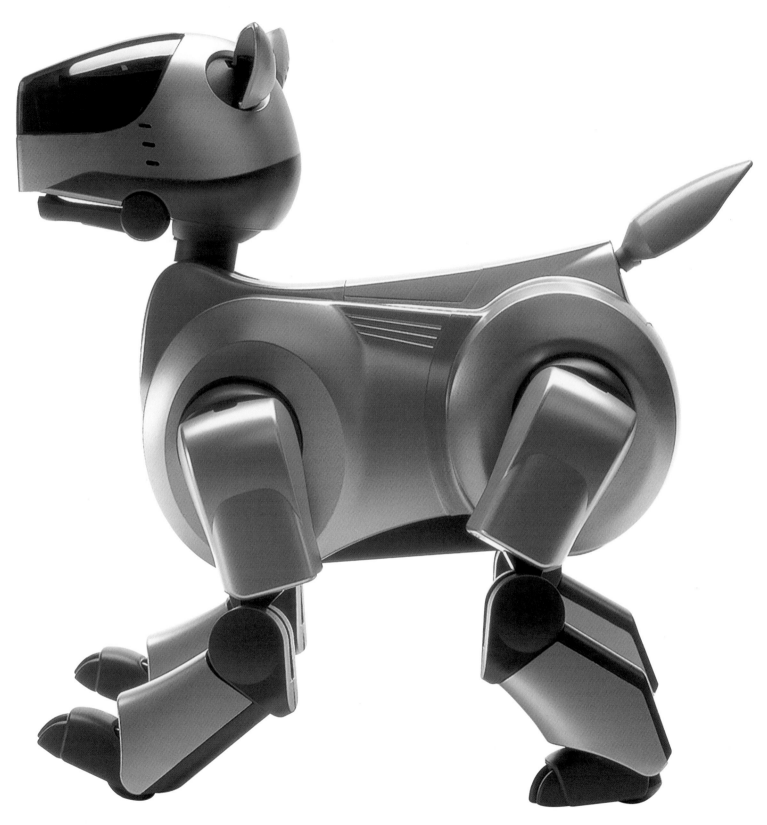

The first Aibo to go on sale is a design classic, creating a completely new aesthetic language that incorporates a science-fiction style of metallic limbs, multi-directional sockets and an abstract but characterful face. The techno-style ears are not powered but are left free to move with the head. The proportions are much more successful than the early prototypes, with the head and limbs reminiscent of the puppy they imitate.

Aibo is a beautiful and sophisticated creature that acts like a puppy and, from its initial position, priced at $2,000 as the ultimate toy, it has gone on to achieve a cult following and the spawning of a huge industry of less sophisticated and cheaper copies. There have even been conspiracy theories that Aibo's cameras were photographing our homes to one day reveal our behaviours and buying patterns. But no matter whether people treat Aibo as a pet or friend (and some people do), or as the ultimate chic style statement, Aibo is the starting point of a whole new way of thinking.

### Speaking back

Even intelligent products around us remain static and standardised in their behaviour. As Richard Seymour has pointed out, the bank ATM machine does not say, 'Hello Richard, is it the usual today?' even though it has the intelligence and data to do so easily. Our mobile phones have begun to offer physical and software personalisation, with snap-on covers, screen logos and of course the personalised ring tone. For most of our products we assume that people would not ever pay the additional expense for the 'gimmick' of animated mobility, voice activation, or personalised responses.

But in a toy, we think differently. People have been more than happy to pay for the delight to play and explore how a little robot dog might emulate the real thing. No product other than a toy, apart from those with military applications, would have such complexity, so many parts, such intelligence and be so cutting-edge in the exploration of behaviour characteristics.

Aibo makes our more conventional products look crude and makes us realise how slow manufacturers have been to use the technology at their disposal to create objects that would enter a new dimension of interactivity. Of course Aibo is a fun thing, but if that amount of design effort was put into a piece of medical equipment, or products to assist the disabled, in everyday objects for work and play, we could be creating an enhanced world accessible to everyone, of whatever age and ability. If Aibo is an indication of how our products might work, let's hope the route is travelled down.

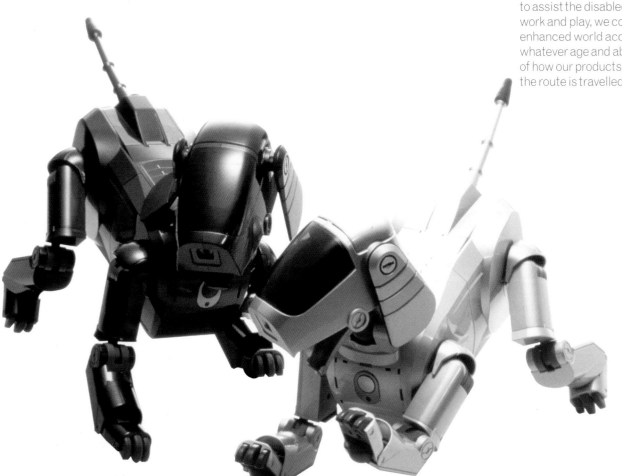

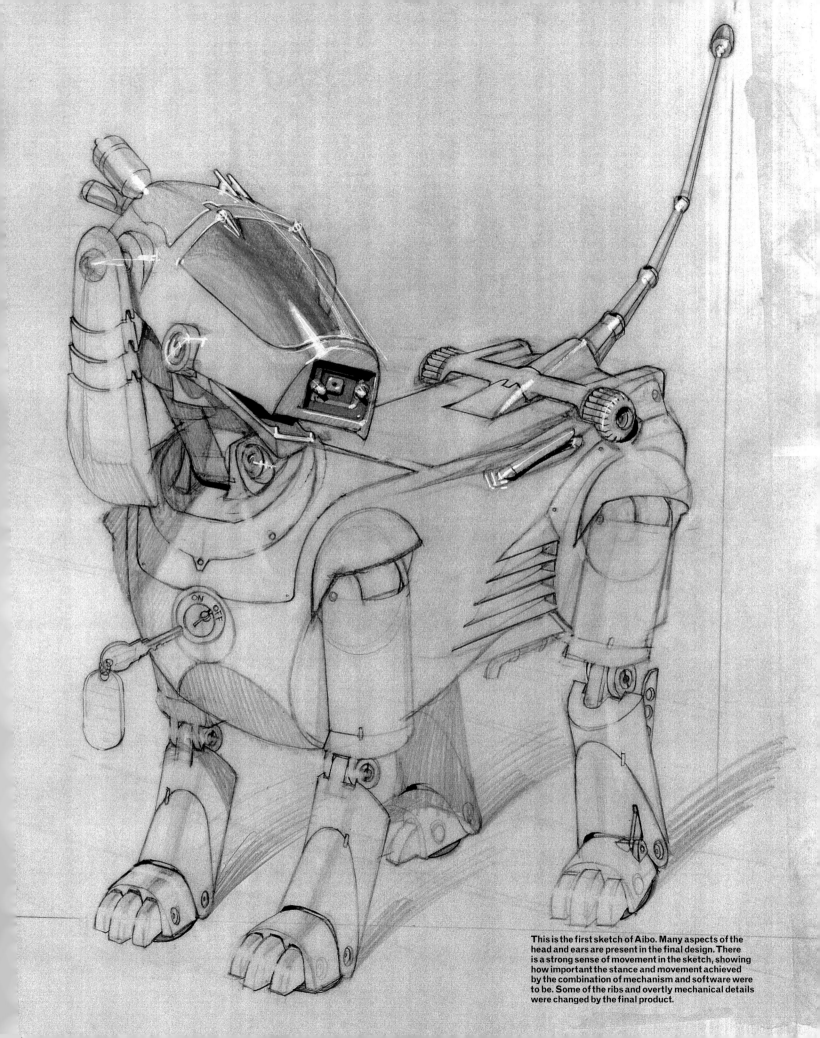

This is the first sketch of Aibo. Many aspects of the head and ears are present in the final design. There is a strong sense of movement in the sketch, showing how important the stance and movement achieved by the combination of mechanism and software were to be. Some of the ribs and overtly mechanical details were changed by the final product.

Aibo was programmed to respond to bright pink, a colour deemed so unfashionable that it would be very uncommon in a domestic environment. Aibo's favourite toy would be a pink ball, easily identified by its **IR** sensor that provided the ability to identify objects and respond accordingly.

76

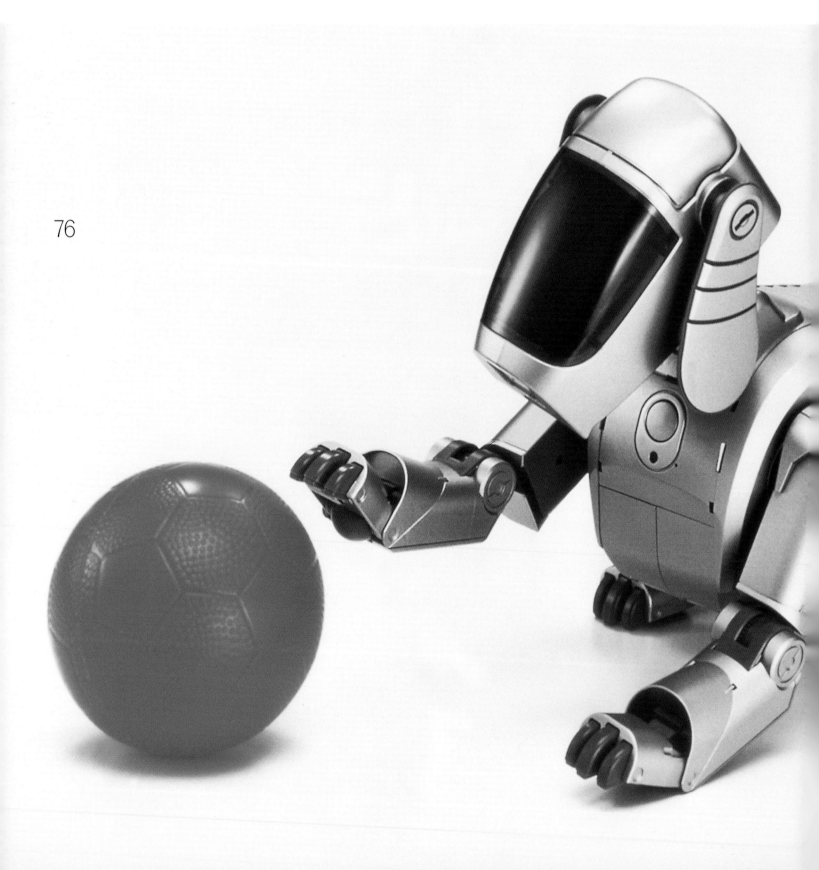

In this updated version some of the characterful style of the original has gone. However, the software is much more sophisticated and Aibo now incorporates Sony's Memory Stick, a portable solid-state memory device. This allows Aibo to be personalised to your requirements and also record events and when asked by shouting 'take a picture' will take a dogs-eye view of the owner. The ears now move, to add to the gestural and communicative elements, and an **LED** in the tail lets you know Aibo is at rest.

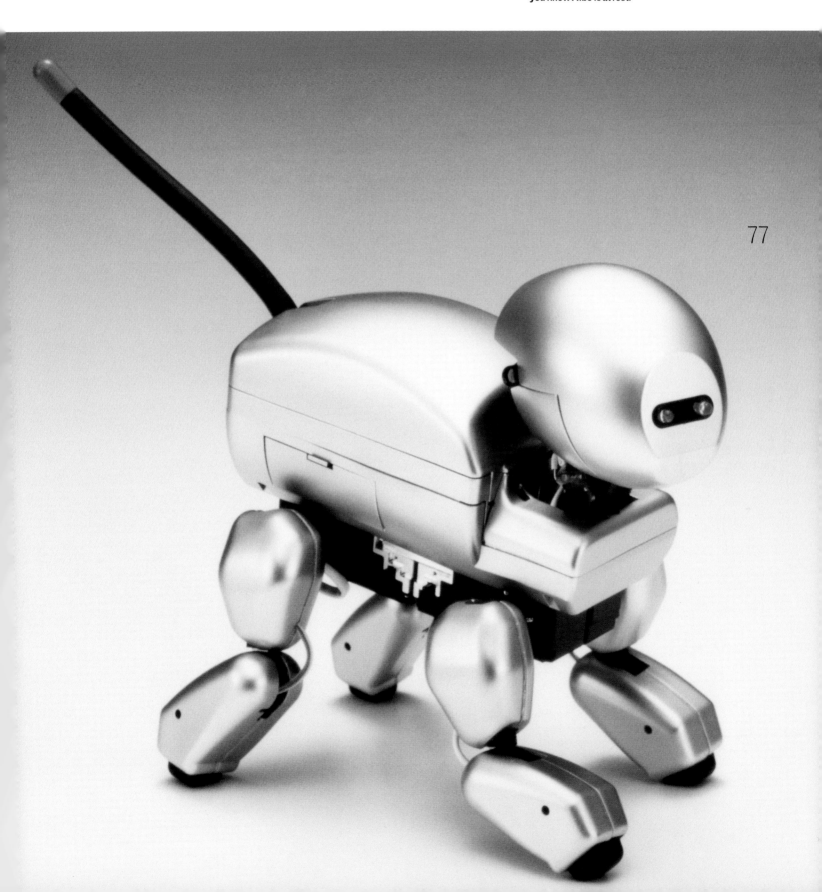

# Hannibal Tape Dispenser
## Rexite
### Design: Julian Brown

## A cultural icon on our desk

Smart design can be found in the simplest of objects. It is not just in technology that problems of functionality, understanding and beauty in mass-manufactured products are addressed. Objects that deliver a service can be mundane or they can be beautiful; they can be blandly generic or they can be intriguing. They all work and need not be more expensive; it's just that some work with beauty and style, and some do not.

The Rexite tape dispenser does a simple job in a surprising and engaging way. From an entirely functional appraisal of how to dispense tape with one hand comes a product of great character and presence, an intriguing closed helmet which then magically transforms into an elephant – abstract, engaging, and entirely functional. Hannibal is the most logical of designs and the most entertaining, showing how the most basic of objects can possess humour, sophistication and delight, whether static or in use.

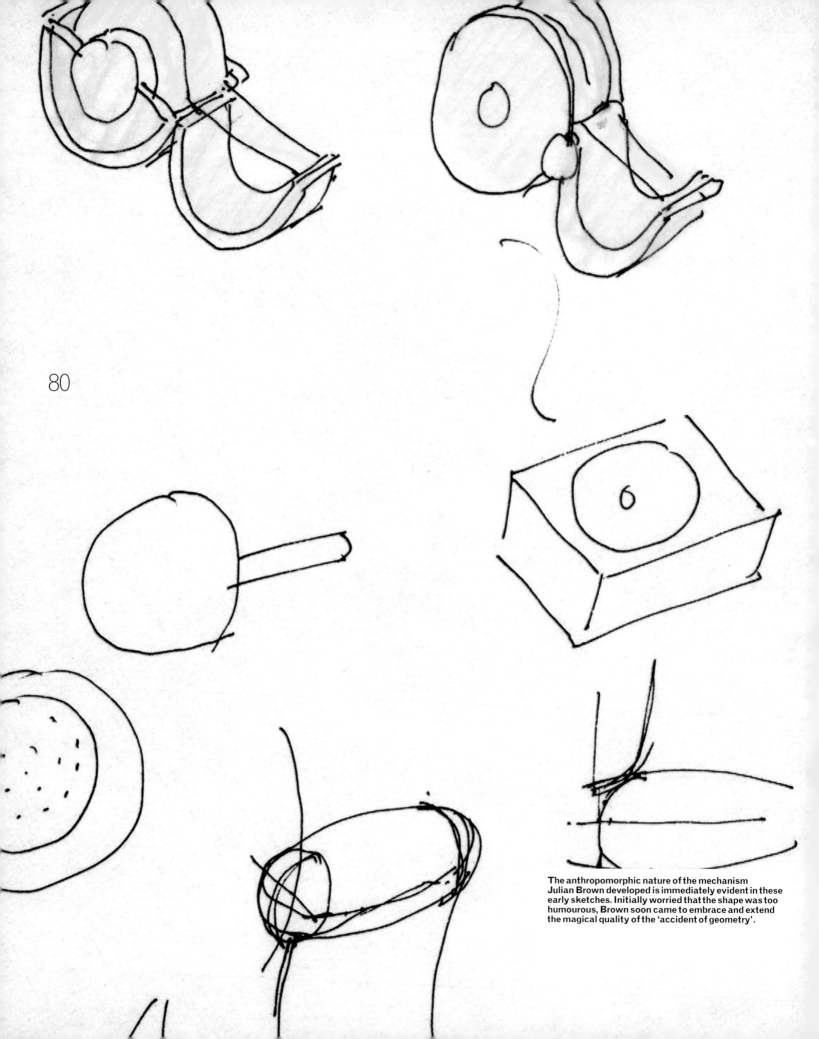

The anthropomorphic nature of the mechanism
Julian Brown developed is immediately evident in these
early sketches. Initially worried that the shape was too
humourous, Brown soon came to embrace and extend
the magical quality of the 'accident of geometry'.

Hannibal was designed by independent designer Julian Brown in 1994 for Rexite, an Italian company with a history of commissioning contemporary and innovative designs for office and home accessories. Rexite had first worked with Julian Brown on the Vercingetorige clock, an alarm clock of great simplicity and audacity which was moulded in translucent plastic. It was one of the first products to use plastic in this way.

Rexite asked Julian Brown to look at a series of three desk accessories as a family: a tape dispenser, stapler and hole punch. The brief asked for the tape dispenser to be used by one hand only. Apart from that it could be whatever form he wanted. For Brown, this mundane item on our desk tops was made dreary by market, price and manufacturing efficiency: 'efficient, yes, but desirable, no'. The tape dispenser was at the lowest rung of the evolutionary ladder, 'a necessary evil, required only to drive the sales of the tape itself.'

Setting off to create something innovative, functional and beautiful, Brown took an analytical approach to the most fundamental principles of dispensing tape. Taking the tape roll, 19mm thick and 60mm round, he set up a series of rigs to see how the tape could be pulled and cut, and to work out the forces and mechanisms to allow this to work single-handedly. He made simple observations about the way the tape exits radially (perpendicular) from the roll, no matter whether full or empty. He tested how much weight and what materials would give him the friction to stop the tape moving while the tape was unwound.

Working with the cutting blade the required distance away to grasp a new piece of tape, and the height above the table surface needed to pull the tape downwards to cut it, he developed the basic geometrical relationships and began to, as he puts it, 'join the lines up'.

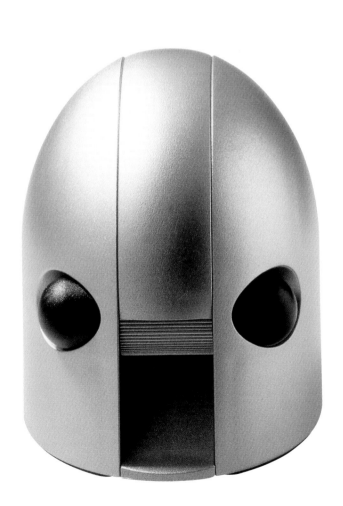

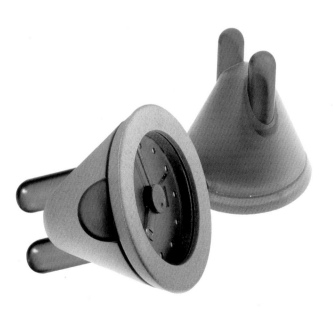

**Brown's first project for Rexite was the translucent clock called Vercingetorige, which became a global best seller. The experience with clear plastics helped in the design of Hannibal, where internal ribbing creates a sense of solidity and depth to the plastic.**

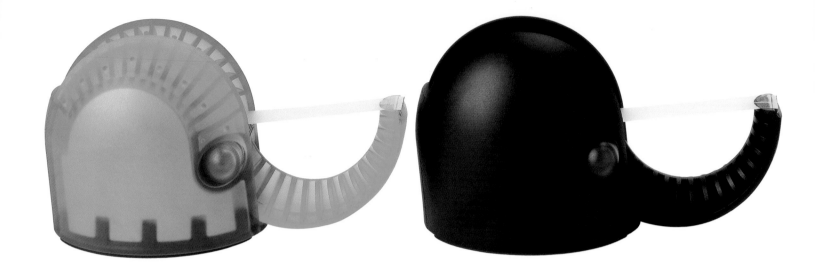

82

But creating a coherent shape was not as easy as joining the lines up. Brown wanted to create stability around the tape itself and extend the form either side to remain dense and compact. Experimenting with the geometry and tracing with a pencil, he developed the line of the tape outwards to meet the cutting blade hovering some distance away to create the shape of a comma. This shape struck the designer as simple and logical, and with an additional animal quality of a mammoth or elephant. Initially resisting the mammoth idea as banal, he was drawn by the purity and simplicity of the outer curve of the tape when simply rotated out to become the 'trunk' at the point to tear off the tape. He realised that by this geometric freak he could rotate the tail of the comma back to integrate it into the main shell when closed, keeping the tape dust free.

From this 'amazing accident' Brown developed through a series of sketches and models, an elliptical form to contain the tape and trunk, with a flat base, cut at an angle to offer the tape towards you. Finally, using the extensive experience Brown had developed with Rexite of moulding in transparent plastics, he developed with as much care as the outside, the sections that needed ribbing to prevent the outside shape 'sinking' where the plastic is too thick. Using radial ribs for the trunk and tape cover create a nautilus-like shell construction that gives an extra dimension to the product when transparent, though it takes twice the work to complete.

As Brown puts it 'Hannibal is a product of the heart with a message of humour entwined with functionality; neither dominates but each serves to reinforce the other.'

**Hannibal comes in many forms, some opaque and some translucent. The two completely different characters of the object when closed and opened are part of the fun and satisfaction to be gained from the intelligent treatment of such a simple object.**

Design in all our moments
Hannibal is an icon of style and humour,
a definition of the functional and emotional
aspect of design. It's also proof that, no matter
how many people think there is just one way
to do something, there is always an alternative
that a creative mind and a patron hungry
for that most special value, uniqueness, can
create. There was no market research required,
no examination of competitive products,
except maybe to avoid them. Hannibal is one of
the most complete examples of function, form,
materials, engineering and manufacturing
to create art in a simple object that gives a lift
to a clichéd and generic world.

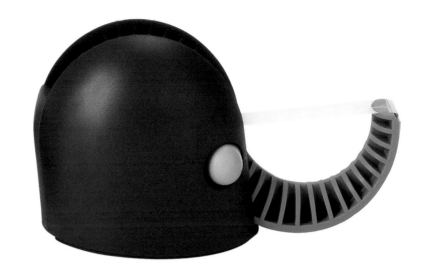

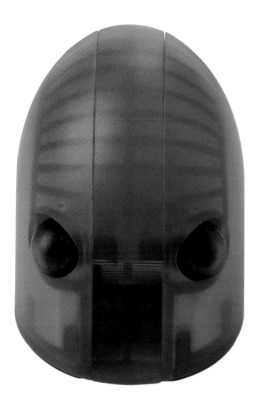

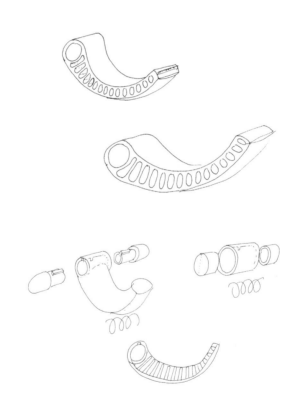

**The visual aspect of Hannibal had to be defined
on inner and outer surfaces because of the use of
translucent plastic. In any design, the form is the result
of what is under the surface, but this is even more evident
when the surface is transparent. The mechanism and
assembly process had to be clearly understood before
the design could be finalised, and in these sketches and
simple CAD drawings Brown builds towards the final
design to be manufactured.**

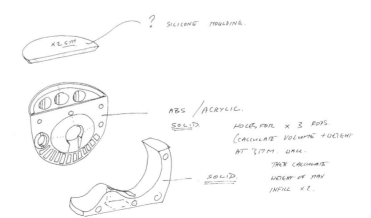

ICD+
Levi's Industrial Clothing Division
Design: Philips Design

## Wearable technology for the urban warrior

The miniaturisation of electronics has been one of the driving forces for innovation and the acceptance of technology in the last thirty years. Refreshed by the rise of digital technology, our ability to carry information, communicate, and listen to music has, as Stefano Marzano of Philips Design has commented, made us forget what it is like to look for a phone booth, or listen to music only at home or in a concert hall.

But the devices we carry are separate and individual, forced into our pockets and bags and disconnected to each other, working in isolation and to different systems. If we want our technology to be invisible and transparent, but instantly available and responsive to our specific needs at specific times, then we have to do more than just consider the product. We have to consider the architecture of the system, the framework that it hangs on and works through. We have to embed the technology into our socio-cultural reality. In other words we have to wear it.

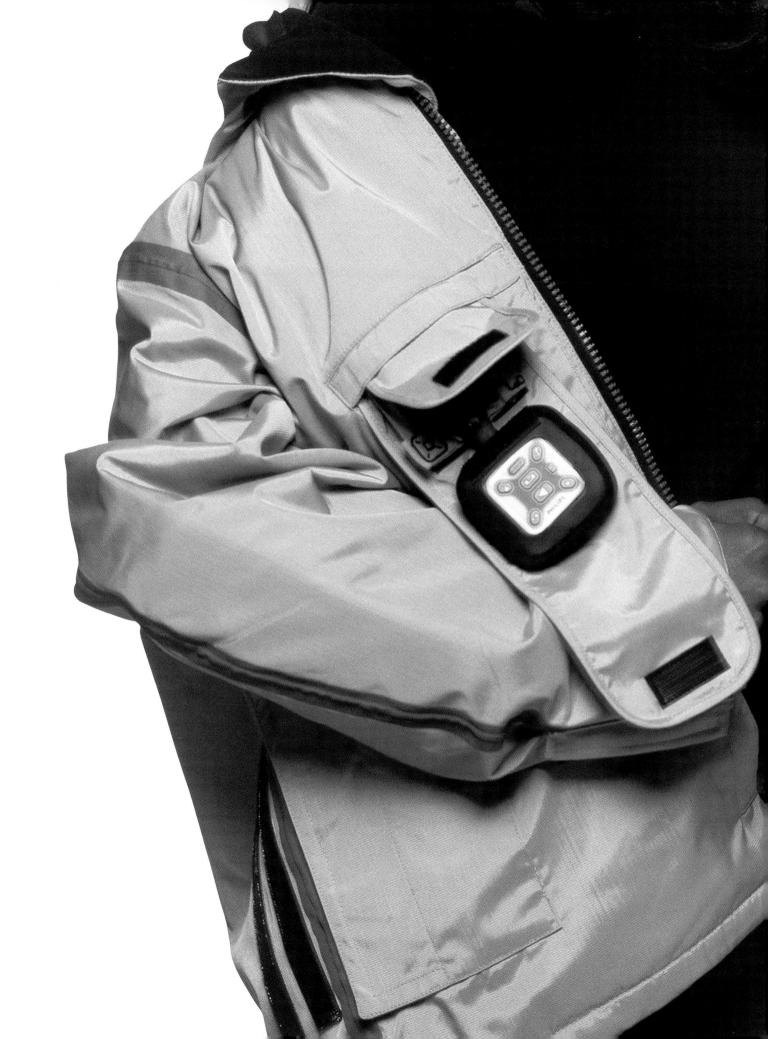

In 1995, Philips, with the philosophy that the future is what we make of it today, created a research project to visualise how our tools for life would be influenced by society and culture, market and technological trends. This 'Vision of the Future' became the vehicle for the development of Philips' design strategy but more importantly created a detailed scenario of how people will live. A main theme of this project became connectivity, through electronics, but delivered with comfort and freedom.

In the 'Vision of the Future' several design concepts around wearable technology were developed, including musical T-shirts, solar cells and earphones, ski jackets with geographical location devices and other items incorporating cameras, displays and microphones. From this work came the concept of PAN – Personal Area Network – that allows the integration of data, power and control systems into the users' personal space.

This vision was, at first, simply a vision, a signpost for future development. Philips was aware that the drivers for these innovative ideas would ultimately come from commercial interest, and the technology required to embed electronics into fabric was still at a conceptual level. Institutions such as the Media Lab at the Massachusetts Institute of Technology (MIT) have been exploring how computers can be worn, but their solutions have been highly technical and oriented around specific tasks, not the leisure and entertainment applications that Philips was using.

Three components allowed this project to turn from a vision to a reality. The first was the realisation that young mobile urban consumers would use a collection of technologies to communicate with each other, listen to music on the move, access personal information and data and need security from the elements and other people. Another component necessary was the technology to weave circuitry into fabric, to print connective materials and to have low-energy, robust and miniature electronics that could make what once seemed fantasy reality. Finally fashion, the factor which integrates the innovative and the new into desirable, functional and emotional reality that we want to buy.

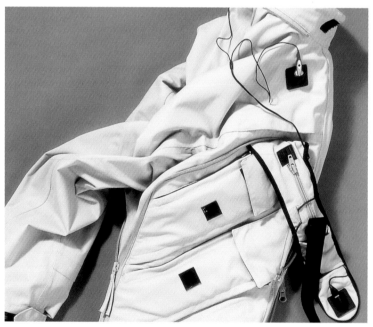

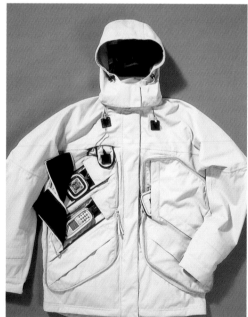

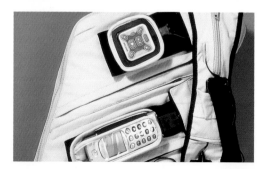

**The storage jacket is based around metropolitan bike couriers. The Philips components fit in a shoulder bag from which the jacket folds out. At the heart of the ICD+ system is the connecting and remote operating system, that allows all the different products to be operated from a single point. The cell phone can be answered, the CD or MP3 track changed, all through the large, navigation buttons, designed to be used blindly and with gloves.**

The origin of Levi's as a maker of industrial clothing has fired this redefinition of functional apparel. Taking a rain mac as the starting point, **C**agoon is first a sleeveless jacket, which unfolds into a full garment. The **P**hilips technology is connected through the jacket and accessible through the pockets in the layers. **C**agoon takes account of the seasons by expanding from the jacket to the coat, an important consideration if your clothing is wired for communication.

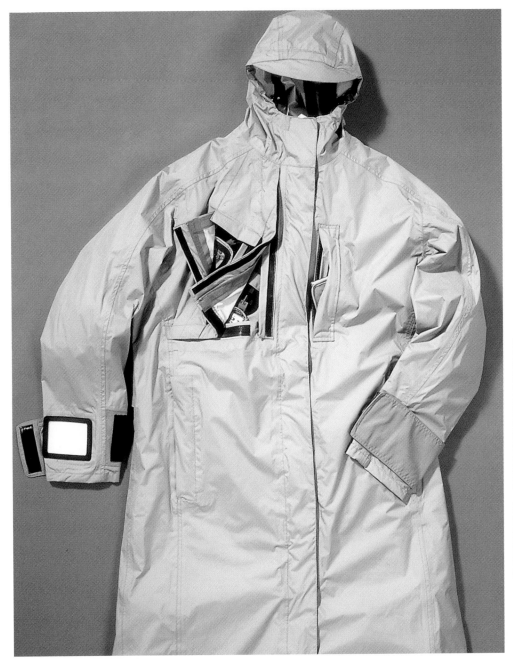

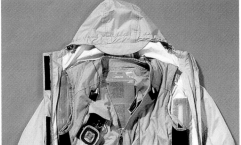

The partnership between Levi's and Philips to produce the Industrial Clothing Division products is an interesting and unique marriage. Levi's represents a huge global fashion statement grown out of the humblest and entirely functional industrial clothing. So ICD+ is the marriage of design, technology (of materials and electronics) and fashion.

But this is much more than just pockets in a shirt or a clip on the belt. Real integration means speakers in the hood of your jacket, a microphone in the collar, a keyboard and display in the sleeve, and all connected through the fabric of the jacket. Most importantly it means a central control system that shares the functions of different applications, a voice-controlled input device that activates the phone, MP3 and CD player, and the same display showing phone information, emails and access to the Internet.

**MicroClimate** (above and below) cuts out the pollution of the city and pumps in sound and communication through speakers in the hood and a microphone in the air filter mask. The designers have created a garment first, and then given a small hint of the functions inside. The first examples of wearable technology emphasise the protective nature of clothing, whether from weather, pollution or personal security. **New Nomads** extends this into leisure, relaxation and social interaction. **ICD+** (right) also champions personal security, using tough, protective fabrics, and incorporating the technology within a part of the garment which is easy to access.

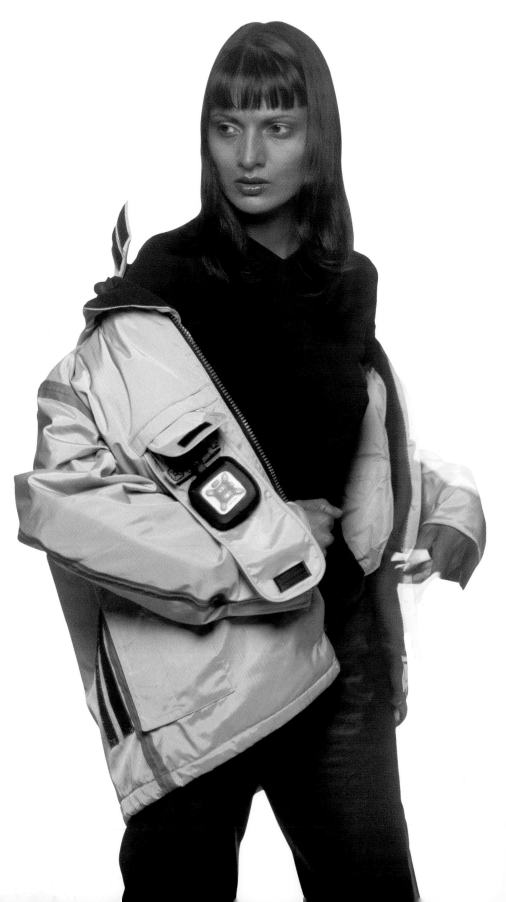

At the heart of each of the jackets is the Unified Remote, which can control and connect the disparate products together, where phones and MP3 players can be removed from the jackets. The Unified Remote is woven into the jacket and encased to protect it from the weather, removable just for washing. Each product is connected to nodes with sophisticated electronics carrying data through circuits embedded in the fabrics.

Fashion and textile designers worked alongside industrial designers, technologists and human interaction specialists at Philips Design and Philips Research in fusing fashion and technology together. Jackets are designed around specific activities. Scooter riders, film crews, outdoor hikers, urban warriors and the fashion conscious are the vehicles for this radical reappraisal of fashion.

The ICD+ range is the first tangible result of this fusion and demonstrates a brave proactive step into what will surely become commonplace. It represents a logical progression from portable electronics and illustrates how we can converge technology and still be able to use it, even if, in this case,

the products have to come from the same manufacturer. But ICD+ is not a pie-in-the-sky concept; it is a real product we can buy, and not based around professional or industrial use, but life activities, built to connect and survive in hostile urban and natural environments.

Past the reality of the Levi's/Philips hook-up, Philips has moved on in its research to explore what they call the 'New Nomads'. Extending the concept of wearable electronics to sportswear, children's playsuits, club wear and environmental protection, they are showing the possibilities of total wearable connectivity and what Stefano Marzano terms the 'empowerment' that comes with it, taking us 'one small step further along the path of human fulfilment.'

89

**The concept of technology embedded into clothing came out of Philips' innovative 'Visions of the Future' project. As the materials required were developed and the ICD+ project became reality, Philips has gone on to develop new applications for wearable technology. The New Nomads project looks to contemporary patterns of life as people live and travel across cities and continents, combine education, work and leisure and develop different types of social interaction. The designers developed concepts around scenarios that explore individual emotional states of mind around different activities. Technology is used not just for communication or entertainment: Feels Good uses sensors and low frequency vibrating pads to gently stimulate the body across the back and arms. The long flowing jacket enhances the Zen-like feeling of relaxation and suspension of time.**

## Brand wear

It has been predicted many times that products will eventually disappear leaving only the services they deliver. Rather than have televisions, our walls will magically turn into screens which we will talk to when we request what we wish to watch. ICD+ is perhaps the first step towards this, as the discreet technology ports of phone, MP3 or CD player and personal organiser become integrated into clothing. What happens here, though, is that the clothing itself begins to express character and purpose, using subtle clues to signify its connectivity. Truly the ultimate smart product, the clothes give protection, security and control and begin the process of convergence of different technologies and the means to control them together. The battle ground will be with the systems that control not our computer software, or even just our cell phone or palm top, but the systems that give us complete mobility and which can connect us whether we are at work, at home, or in transit between the two.

Combining brands which are very different but each trustworthy in their field is one way real convergence will happen. It shows our dependence on brand to communicate expectations, for we would be unlikely to buy electronics by Levi's or clothes from Philips, but co-branding in this way creates a carrier for these innovative new products which make sense to us. The idea of one omnipotent brand owning the whole world is less likely with convergence until you consider the systems architectures they will have to run on. Instead of Nike versus Adidas, Coke versus Pepsi, or CNN versus the BBC, the world is more likely to be divided into owners of the media and the systems such as Microsoft, Murdoch, Cymbian, AOL or Sony.

**Protection, entertainment and communication are combined in the No Kidding concept. The growth of mobile phones in teenage and younger users was one of the surprises of the telecom revolution: wearable technology for kids makes sense in an easily threatened world.**

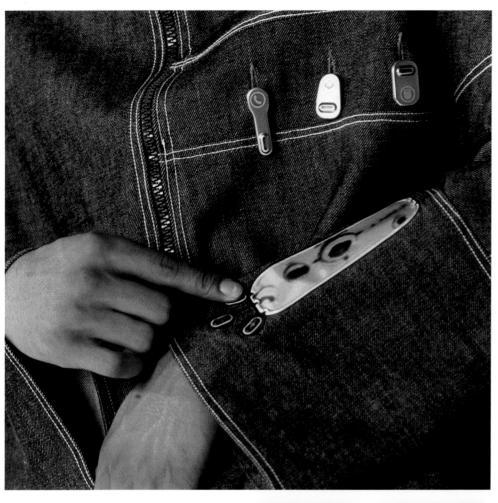

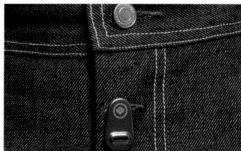

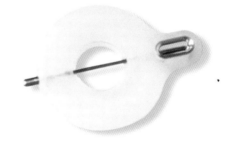

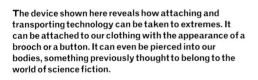

The device shown here reveals how attaching and transporting technology can be taken to extremes. It can be attached to our clothing with the appearance of a brooch or a button. It can even be pierced into our bodies, something previously thought to belong to the world of science fiction.

# Art Couture
## Sony Corp
TV Design: Yoshimichi Matsuoka,
John Tree, Philip Rose, Simon Bradford
VHS/DVD Design: Philip Rose, Jun Uchiyama

## TV as furniture

Sony made TVs sexy. Since the earliest of sets, TVs were spherical glass lenses, pointing out like fish eyes from plastic surrounds. TVs have always been big, and always been expensive. Until the rise of the Personal Computer, the TV was the most expensive purchase kept inside the house.

Its size meant it always dominated the living room, at the focal point of sofa and chairs. A platform for pictures and plant pots, it possessed a symbolic role in 20th- and 21st-century homes. Sony understood the importance of design in TVs, and their technical innovation of the Trinitron screen that is vertically flat and curves away from you east-west, allowed their designers to create sleeker, more modern designs than their competitors. Sony has arguably become the brand name to own in TV and household audio, with the high ground in terms of audio performance combined with a sense of design and technology through pure simple designs that leave a lot of space for the all-important logo.

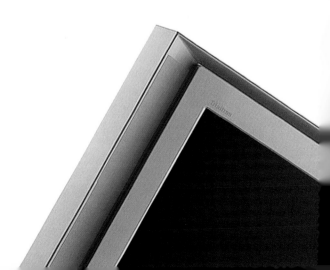

Sony's Art Couture represents a new trend in TV design where the importance of the TV itself as a piece of furniture or interior design has become the driver as much as the technology. The expanse of flat screen has become so large that it needs its own support and shelving for DVD and Cable boxes. Sony's designers took this as an opportunity to change how people looked at their TVs and to move them away from a piece of audio-visual electronics to a piece of art and style.

The designers have changed just about everything they could have from conventional TV design. The frame around the screen is not a continuation of the glass – it turns back in and creates an architectural frame. The speakers hide behind these surfaces, pointing towards the viewer and pricked with a texture of holes to let the sound out. The gradation of light and shade of the surface between the display and cabinet reinforce the feeling of floating.

Art Couture has a sense of architecture and contemporary design not usually associated with something as mundane as a TV. Purposefully designed to reflect European tastes and preferences, Sony has made a unique design statement that reminds us that, no matter what is on the screen, and no matter the cleverness of the technology inside, we still have a strong relationship with the physical object. We care as much about what it looks like when it's turned off as we care about what comes through the screen when it's on.

94

**Under the TV are placed elegant supports for the DVD and other boxes. The DVD and VHS Video boxes are designed to match the feeling of lightness and space of the TV. The materials are glass and finely ribbed metallic fronts, with simple and straightforward controls; a strong European preference over the complicated, multifunctional technological appearance more often associated with video equipment.**

## Shadows on the wall

What will happen to TV? Won't it be better to have a projector, rather than a screen? Will the slimness and clarity of flat LCD screens become the norm when prices, as they inevitably will, fall to within the range of our pockets? Will we only know what TV we have by a discreet little label on the wall, or on the remote control we hold, and will we care?

During a transitional phase of TV, there has been a re-birth in the importance of design to let us live with something so large and prominent in our lives. This reflects the importance people actually place on beauty and style in their homes, and the effect something as large as a TV can have. And if the screen becomes transparent, we'll loose that ability to make a statement, to be proud of what we own, and to broadcast our good taste.

95

The TV's structural frame strongly emulates the architecture of **La Defense in Paris. The TV** is elevated on three legs. The complex structure allows the TV to appear to float and, as the designers describe, 'was very challenging for the mechanical engineers, but conceptually vital to the designers.'

Premium Line
Bosch Siemens
Design: Porsche Design
Studio Head: Dirk Schmauser

## Creating an icon for the breakfast table

Siemens, as one of Europe's largest and most successful companies, has always taken design seriously. But when it came to mundane products like kitchen appliances, it was more difficult to find the quality and rigorous engineering found in Siemens' professional or medical equipment. Their range of domestic products, in line with those of their competitors, were designed to be utilitarian and cheap to manufacture.

In the early 1990s Philips, in partnership with Italian couture manufacturer Alessi, created a range of kitchen appliances embellished with form, colour and style. They showed that these objects were more than just tools for preparing breakfast, but strong statements of personality and style. They become kitchen furniture, as important a part of the kitchen as the chairs and table.

Siemens wanted to change people's attitudes to the products they made and the company they were. To do this they joined forces with a design company whose values and philosophy would combine with their own to create a range of distinctive and opinion-changing products.

Working with external designers is of course a common thing. Siemens has one of the largest in-house design teams in Europe, but working with outside designers provides fresh vision, a different point of view gained from experience working in other industries and other markets. Design consultants can bring clarity of vision unaffected by the day to day politics of the corporation.

Only an elite few designers in the world establish such strong associations that their names placed on the product create their own marque of excellence. Philippe Starck, Guigario, frog design, or Mark Newson are examples where the designer's name says more about a product than the manufacturer's. Another example is Porsche Design. Started by Ferdinand Porsche's grandson, FA Porsche, in the 1970s, the logo 'designed by Porsche' has come to imply an uncompromising purity in form and materials when applied to watches, knifes, luggage or sunglasses. Porsche represents a timeless classicism strongly linked to the great German design tradition – everything, in fact, that Siemens were looking for in their new products.

The early sketches show how the toaster and coffee maker were considered at the same time to explore how a strong design direction could be applied to products which work in quite different ways. Dirk Schmauser, Head of Porsche Design, describes the project as initially 'disastrous – we had five concepts and even I didn't like them'. But Schmauser did see elements of each that could be combined and asked Siemens for something not often given in design – a second chance. 'The second design was perfect,' he says, but Porsche was still one of three different design companies submitting design proposals. To decide which one to choose and then manufacture, Siemens market-researched the designs with potential customers.

Market research is seen by many of the larger manufacturers who can afford it, as the ultimate arbiter of design. Asking people which they like is seen as fail-safe, letting the customer choose. Designers have got used to responding directly to consumer views, but there is the suspicion that the conditions of market research are unreal and therefore flawed. There is also the worry that the public tends towards safer, more familiar options, which can penalise innovative designs. Would the design of the iMac or Dyson have passed market research? They may have, but if they hadn't, many companies would have shelved them right there.

For Porsche Design the initial news was bad. Their products were liked, but a different concept was liked more. Siemens felt that Porsche's designs were so in keeping with the brand values they wished to build that they rejected the research results and stayed with Porsche, going ahead with the range. 'Sometimes we need companies to behave as the entrepreneur, willing to take a risk if they believe in something,' says Schmauser.

The combination of sleek aluminium cylinders and softer plastic is seen in this concept sketch. The purity of two connected cylinders is severe; the curve of the handle creates a contrast that carries through almost without variation to the final product.

The preliminary sketches show the struggle to make a similar theme between the differing architectures of the coffee maker and the toaster, one vertical and the other horizontal. It was important to Porsche to consider the two together, as a family feeling was vital. As these sketches explore, this might be achieved by material, texture and colour, as well as through a strong form.

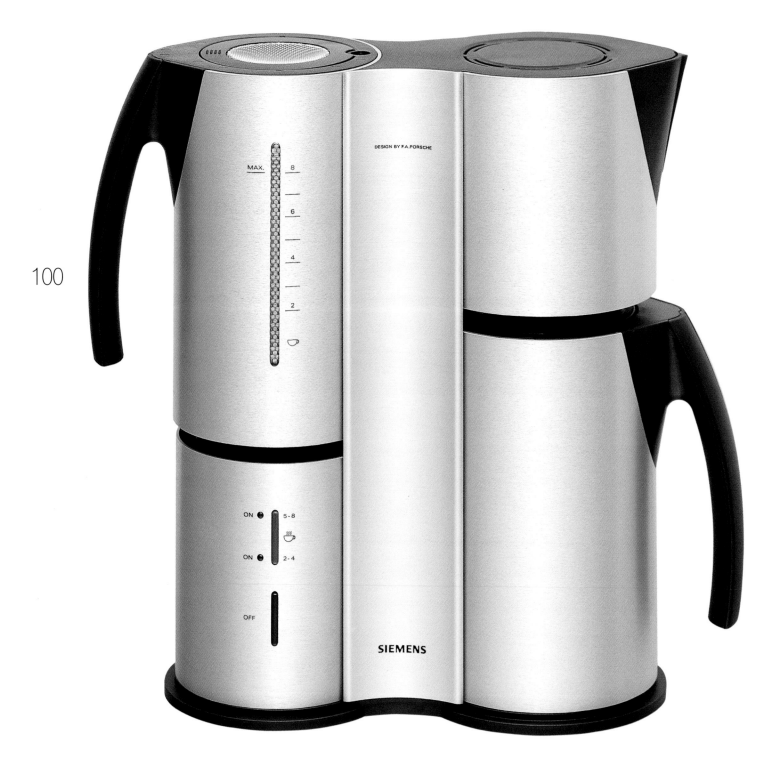

MAX.  8

6

4

2

DESIGN BY F.A.PORSCHE

ON ● 5 - 8

ON ● 2 - 4

OFF

SIEMENS

The two aluminium cylinders of the coffee maker in the finished product link the water tank and the jug. The strong vertical component of the design is strengthened by the water level and operating LEDs. Although the water jug and coffee pot unplug, they are mostly seen in this combined way, where the joins and meeting points of different materials are engineered to perfection. The absence of large clearance gaps gives a sense of precision and high quality which is unusual in domestic products. But most striking is the natural aluminium finish, such a contrast to the fields of white plastic more usually associated with this type of product.

The finished pieces are a testimony to the synergy between Porsche and Siemens, a combination of design purity and of engineering excellence. The thin-wall aluminium construction allowed for the elegance and purity of line described by the designers in all the pieces in the range. 'Siemens' engineering skill can be seen in the way the plastic and aluminium parts come together,' says Schmauser.

The Premium Line sold its target sales for three years in just one year in the US. The reaction of the consumer is still the ultimate measure of success and the Bosch Siemens Premier range is a testament to the fact that high-quality materials, engineering excellence and faith in the designer's vision can lead to commercial success.

## Faith and vision

Faith is an important but difficult word. It implies the immeasurable, the risk, and belief without knowledge. For designers it is often the only word left, when they believe that people will understand and react positively to their vision. Design is both an individual and collective vision, and will collapse if the creator or the implementor lose that sight. At the moment of truth, as people are asked to react to the design, that relationship is stretched to the limit.

Research can lead us to knowledge about how people really think. We can find what they would like to have if only they could. Designers are a vital part of research in that they can show what might be rather than just compare with the present, which is all the worst sort of market research does. If we compare Product A with Product B, and find that people prefer Product B, what should we do – copy it? By which time the manufacturer of Product B is developing the replacement, which will launch just as your copy hits the market.

Design by research is important as a way of finding out what people need or desire, but it's only a tool. In the end, people have to decide. Siemens made a good choice and had the faith to stick with it. Knowing the design achieved what it set out to do was more important than reacting to market research. They made a strategic decision; when design has strategic foundation, as part of the company's brand, you have a mechanism for making decisions. This works, as Siemens and many other companies have shown.

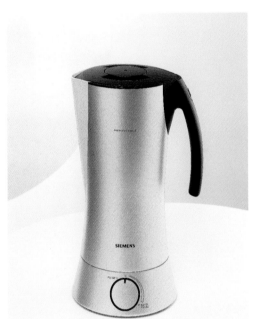

**The juice blender was the last of the range to be designed. Dirk Schmauser found the proportion caused by the sizes of the motor and the container unsatisfactory but the combination of elegant curves and slight oddness of proportion has translated perfectly from this simple sketch to the final object. Compared to the first perpendicular purity of the coffee maker, the blender is more contemporary and more beautiful. The rotary knob in the base is perfectly engineered to create a flush feel, which doesn't interrupt the elegant form.**

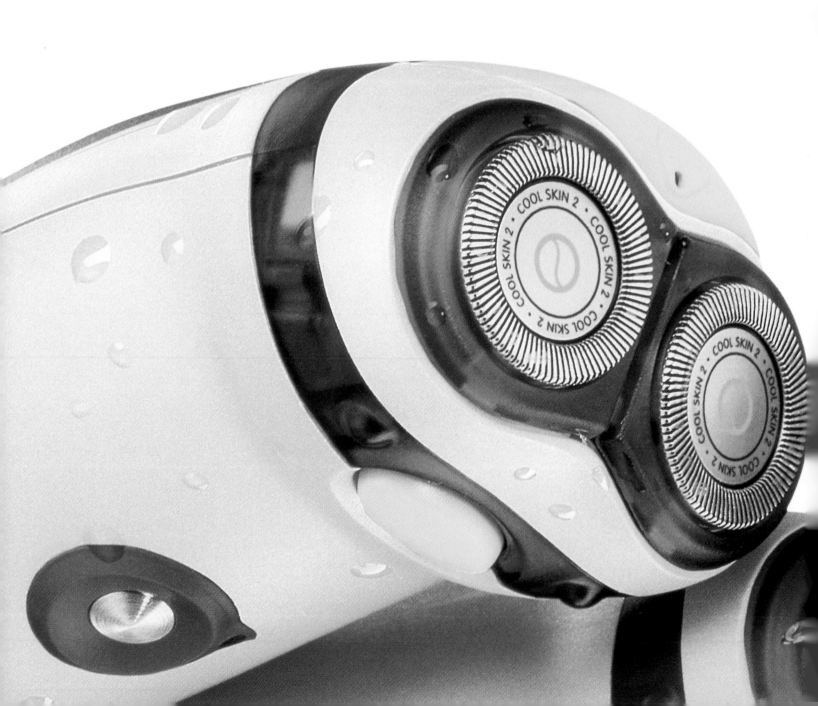

Cool Skin
Philips
Design: Philips Design
Senior Designer: Sam de Visser

## Wet, dry and soft: a new way to shave

The design of shavers has always been very important and some, such as those from Braun, have become classics of 20th-century design. Braun shavers created new manufacturing processes along the way such as co-moulding rubber through plastic to create the famous dimples. In the 1990s shavers were developed that could be used with wet skin and shaving foam in an attempt to combine the advantages of both methods. Philips has created the next development, a combination of an electric and a wet shaver. It is waterproof for use with wet skin, and includes a unique delivery system for moisturising cream, to improve the shave and leave the skin in good condition afterwards.

Cool Skin is the name for a range of these shavers which cross the border between wet shaving and dry shaving. Using the Philips rotary-head mechanism, a series of products using moisturising cream created by Nivea have been developed to suit a variety of users.

Cool Skin is both a technical and marketing achievement. Having decided to aim for wet shaving-blade users who were willing to try a new system, Philips looked to create the mechanics required. It was their intention to provide a refillable compartment in the shaver that could be filled with moisturising cream, but it was soon apparent that bacteria growth would be a potential health problem. A disposable cartridge system was developed which would remove the pump as well, meaning that the minimum of cleaning would be required.

Now the market research started. Agencies were brought in to evaluate the emotions, needs and aspirations of their potential customers. Philips wanted to focus their design on a specific type of male and used the concept of 'Balance in Contrasts' to define the emotions they wanted to see in the design of the shaver.

On the mechanical side there were many problems to be solved. To combine the hard protective case with a soft-to-the-touch rubber feel meant two-shot moulding, where first one, and then the other material are moulded around each other. Even the power button is rubber-moulded around metal; shavers are the ultimate tactile products, their quality and performance perceived through their weight, balance and touch.

The industrial design is a beautiful study in form and approachability. Masculine but not macho, the design reveals great care paid to the detailing. Colour is used to highlight the unique elements of the cream dispensing system, and even the soft pouch is made from neoprene rubber, to emphasise the waterproof quality of the shaver.

**Water proofing electronics is not just a case of sealing them in rubber. The rechargeable batteries form a gas during charging, and this gas must be vented away. A thin ventilating membrane was developed, which lets the gas pass through. In production this membrane is used in the opposite way to check for leaks. The blades also had to survive wet and dry conditions and remain sharp for their life. The Philips blades are 'self sharpening', but many special grades had to be tested before one was found that met the requirements.**

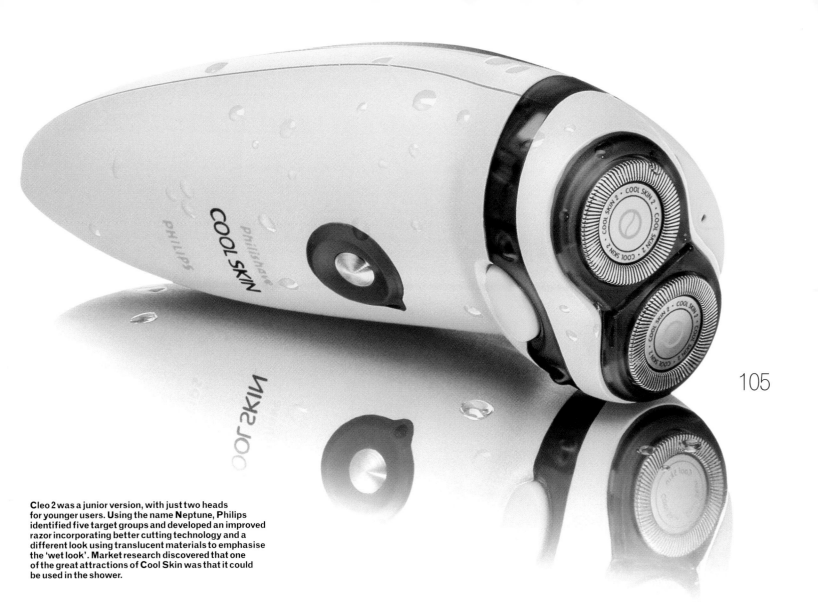

Cleo 2 was a junior version, with just two heads for younger users. Using the name **Neptune**, **Philips** identified five target groups and developed an improved razor incorporating better cutting technology and a different look using translucent materials to emphasise the 'wet look'. Market research discovered that one of the great attractions of **Cool Skin** was that it could be used in the shower.

By combining forces with **Beiersdorf**, who made the **Nivea for Men** products, **Philips** saw that the product was less of an electronic product and more of a men's care product to be sold through quite different channels such as chemists and drugstores. This meant a different attitude to the marketing of the product, and the use of Helmut Newton to shoot the adverts.

For the initial market research, agencies were bought in to evaluate the emotions, needs and aspirations of their potential customers. Philips wanted to focus their design on a specific type of male and used the concept of 'Balance in Contrasts' to define the emotions they wanted to see in the design of the shaver.

Hard product; soft values

Cool Skin is an example of care and attention to detail, in the targeting of the design to particular types of people, and in connecting to those people through related advertising with a single focus and spirit. Of course, this attention to detail is also evident in the development and manufacturing of the unique new system, and in the decision to co-brand with a company known for its cosmetic products, a move which changed how both customers and Philips saw their products. Cool Skin is an example of the sophisticated design manufacturing and advertising that is required in order to protect the huge investments required in generating these types of products.

Exper

Some products we climb into and spend time with. When we enter a car or a plane, we are enabled by mechanics and technology, but it is the macro experience – the touch and feel, the ease of use, and the comfort and excitement – that we remember.

ience

Club Class Seat
British Airways

Design: Tangerine
Designers: Martin Darbyshire,
Matt Round, Mark Delaney

BA team: Michael Crump, Paul Wylde.
Manufacture: Britax Aircraft Interiors

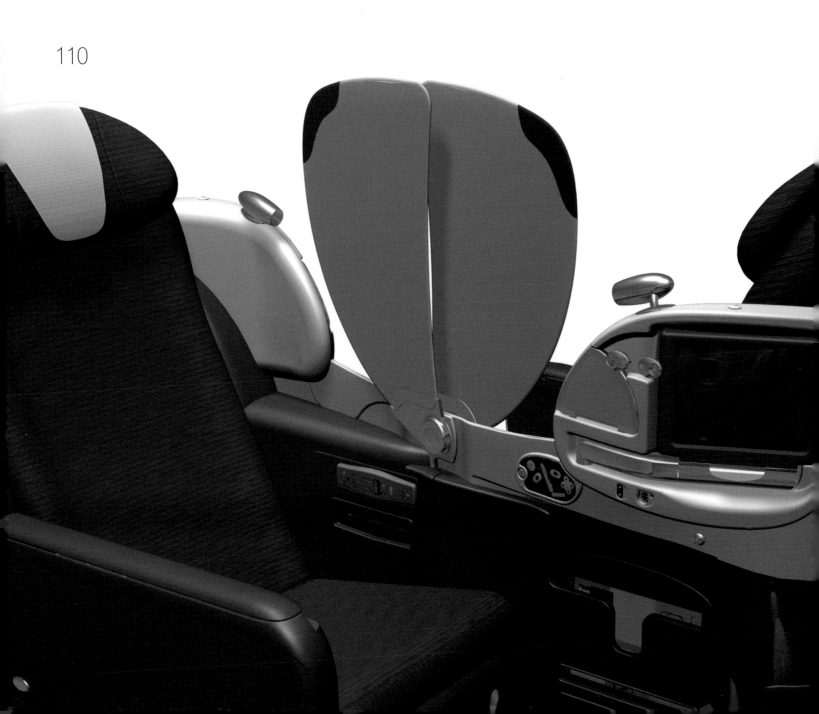

## Sleep on it

The British Airways' new Club Class Seat is a radical and innovative approach to the experience of air travel. At first sight it challenges every expectation of air-travel as half the passengers fly backwards. Within each pair of seats are technologies, mechanisms and design that provide emotional and physical sustenance over a long-haul flight and the means to use time constructively and make the most of the journey.

A company's perception of itself, and the products that it actually makes, are not always the same. Companies strive to build a brand value, a recognition in us all of a name and a level of service or performance we would come to expect and trust over time. Delivering those brand values is not just getting the big message right (advertising) but getting the small details of the service or product right. For us this is noticeable in a pleasant operator at a call centre or the satisfying clunk of a car door. This product is smart not just for what it does and how it does it, but because it's an integral part of the whole business-class service and is a representation of the BA brand.

The competition for business travel has become intense. When British Airways began to develop a new concept for business class, they realised it was necessary to make a quantum leap and create the best business flying experience to leapfrog the competition. As well as creating new standards in service, entertainment, food and all aspects of presentation, they decided to take a radical look at a seat that would provide the traveller with everything they would need and redefine the experience of business travel.

BA had carried out extensive research with their business passengers over the previous 12 months. They found three main themes. Passengers wanted comfort and the chance to rest and arrive fresh and ready to carry out their business. Passengers desired the chance to use the time travelling which would otherwise be wasted. Passengers hoped for an enjoyable experience, rather than just the chore of long-haul travel. From these research findings BA developed the brand theme 'ready to do business'. The look and feel of the service would have this message at its core.

From the very first concepts the design consultancy Tangerine, which BA chose to carry out the design of the seat, focused on achieving a world first: a full bed in business class. The two issues to be overcome involved ergonomics; how to transform a seat into a bed and be truly comfortable; and space, enabling maximum leg room while allowing for the number of business passengers needed to make the fight commercially viable and give them space for a bed as well.

The solution was radical and simple. The concept was to create a seat that folded flat and used a flexible footstool that could double as a work-top for a laptop, a foot rest, or fold away completely for access to and from the seat. When raised to the level of the fully reclined flat seat, the result is a full six-foot bed.

More innovative yet was Tangerine's solution to the space required for such a bed. By turning the seats to face each other the same number of seats could be put into the Business Class section as normal, but there would be room to transform each into a bed. It was a radical concept because it asked half the passengers to fly backwards.

Tangerine worked throughout the process with the ergonomic consultant David Davies. 'As well as conducting sleep trials of the bed with low-lighting video to watch how people moved and slept on the seat, we had to try and evaluate the effect of travelling backwards on the plane.' Research with the Royal Airforce, British Aviation Authorities and aircraft manufacturers showed no negative effects at all. User tests by BA on prototypes showed there were positive perceptions about safety improvements from flying that direction.

Satisfying stringent safety regulations was crucial and creating a seat, which connected to the floor to feel like an armchair, rather than the dentist's seat appearance of conventional aircraft seating, meant research into new improved fire-resistant materials. But with the new configuration comes added opportunities: a briefcase-sized locker is fitted under the seat, space no longer required for the feet of the passenger behind.

112

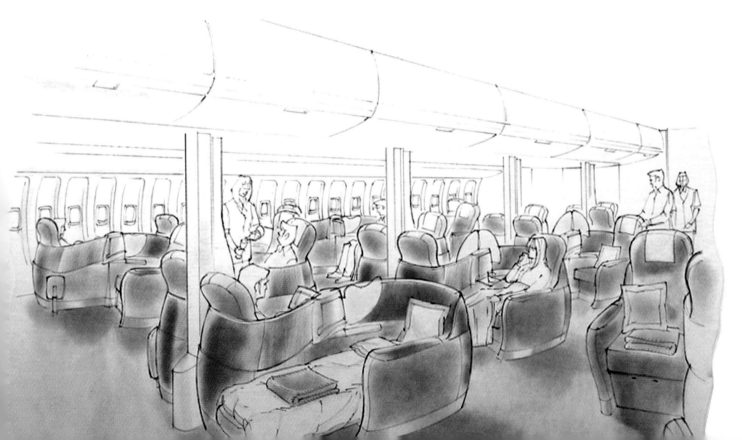

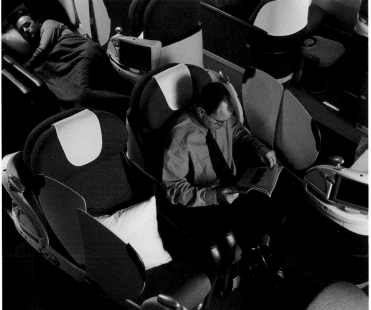

Flat out on business

The overall effect of the seat is one of devotion to the passenger, providing complete comfort and functionality together. From their original brand message of 'arrive ready to do business' BA developed the message 'flat out on business', reflecting the seat's ability to switch from business activity to a full flat bed. It is unusual for a piece of product design to change an advertising slogan but the connection between corporate goal, passenger desires and innovative product design has created a truly smart product, redefining how we measure the quality of air travel.

Having established what the seat was to be by working closely with **British Airways**, the designers moved on to work with the seat manufacturer **Britax**. Here they could help modify and anticipate changes required as the detailed engineering and specification for manufacture work was under way. The designers could hold the values the seat needed to retain to be satisfactory for **BA** and its passengers, as well as understand the engineering issues that arose through development.

The seats are grouped in pairs, which leads to savings in the numbers of components, as versions for left or right aisles and the many configurations needed for different aircraft are no longer required. The seats nestle into each other, wider at body end for elbow room and tapering at the foot end.

A2
Audi AG
Design: Audi Design

## Progress through technology

Vorsprüng Dürch Technik, as they say in Germany. The Audi A2 is a leap forward, progressing car design through materials technology, designed to give the greatest value in terms of engineering efficiency and ease of use. A2 is a seamless marriage of design and engineering.

The smallest car in Audi's range is the most innovative and exciting, developing Audi's expertise in aluminium, rather than conventional steel, to develop an incredibly lightweight space frame of great strength and rigidity. With this at its heart, the A2 rethinks the basic structure of the car to minimise the exterior profile and maximise internal space, safety and fuel economy to create a radical package of thought and deed.

114

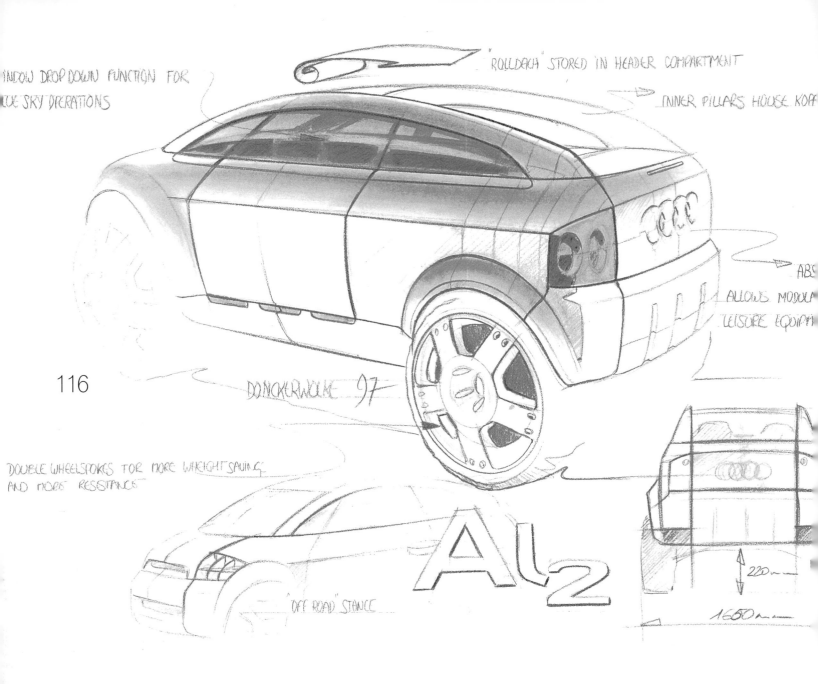

WINDOW DROP DOWN FUNCTION FOR
BLUE SKY OPERATIONS

"ROLLDACH" STORED IN HEADER COMPARTMENT

INNER PILLARS HOUSE KOPF

ABS

ALLOWS MODULA
LEISURE EQUIPM

DONCKERWOLKE 97

DOUBLE WHEELSPOKES FOR MORE WHEIGHT SAVING
AND MORE RESISTANCE

"OFF ROAD" STANCE

Al₂

220

1680

The concept sketches show the character of the A2 with its protective high sides, stance and slipstream design. The A2 logo shows how the designers knew that aluminium was crucial to the concept for its lightness and strength. Even the sun roof is alluded to, as is the emphasis on usability and flexibility across all types of use from leisure to work.

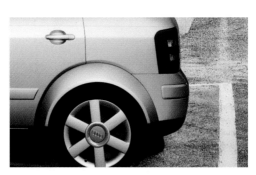

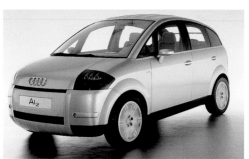

The concept was first shown at Frankfurt and is almost unchanged in the final product. The service module is higher and easier to access in the final design, and replaces the traditional radiator.

The A2 is the latest in a line of innovative ideas around the small car. In Europe, Renault took credit for developing the People Mover, a multi-purpose, multi-seat estate van, based on a saloon car chassis. The innovation was repeated on a smaller scale with the Scenic, creating a flexible urban vehicle of unique character designed around careful study of family use. The A2 continues this tradition of flexible seating, with a small urban vehicle at the opposite end of the sporty TT marque.

At the heart of the A2 concept is an aluminium space frame that provides an incredibly lightweight structure allowing for maximum space and storage in the car. The structure is 40 per cent lighter than an equivalent steel car and weighs just 895kg, 150kg less than equivalent vehicles. Weight loss of this magnitude means a significant saving in fuel costs, an advantage increased by the streamlined shape and detailed engineering which reduces draft-creating edges to a minimum. The marriage of engineering and design leads to super-flush details, especially in the roof and rear window and sun roof. The full-width glass sun roof lifts and slides back in two sections and when closed adds to the feeling of internal space.

In designing the A2, Audi rethought the way we use and service our cars. Creating a new engine allowed the engineers to position all the points that we need access to in one place, through a 'service module' at the front of the car behind a flap. The flap can be flipped down to reveal the oil filler, dipstick and windscreen washer tank. It's a simple innovation, powerful for its obviousness. In addition, technology until recently found at the top of the range is poured into the A2. For example, navigation systems and rear bumper sensors warn of an approaching kerb or lamp-post.

For Audi, 'this innovative new face in the Audi family, is not so much a small car as a new automotive philosophy.' It's a philosophy based on pushing manufacturing processes and material possibility to create a concept based around urban living and real user requirements. The innovations in engineering enable the car to achieve the human requirements at a higher level.

The appearance of the car accentuates safety and usability. Its sturdy high sides offer rigid protection for the passengers, an important psychological tribute in a small car. The car slides through the air with an aerodynamic teardrop shape reminiscent of Buckminster Fuller's automotive concepts. Its form speaks fluent Audi. The straight lines and circular sweeps communicate the values of engineering and the cheeky, pugnacious front links directly to the heritage of the all conquering Auto Union race cars of the 1930s.

117

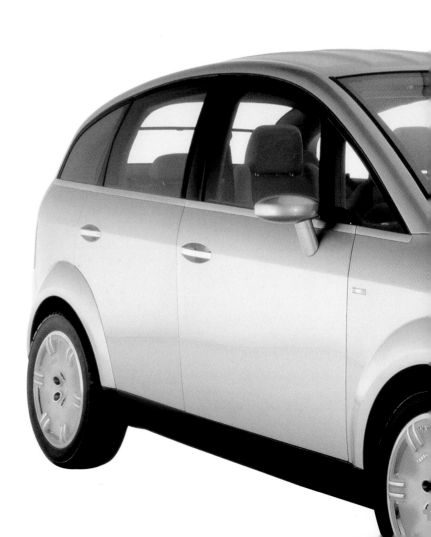

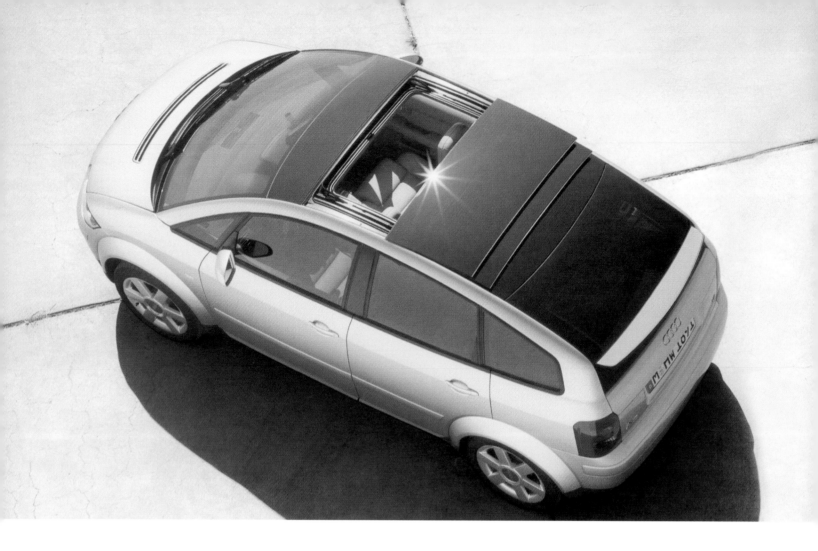

**Engineering the consumer experience**
Car manufacturers are uniquely able to make the links between mass production, advanced engineering and technology, and the balance between our hearts and our brains. Cars remain the most complicated objects we possess, objects we almost completely trust and depend on. More than that, they are tools for life, not just travel, offering solutions for our mobility. After that, they feed our emotions, creating status, making statements about how we make choices and chose to live.

Design is the glue that combines every aspect of engineering and technology to the real people we are. The A2 takes a radical stand, not just in the engineering of its hardware but in the design of its emotional software. It is a new type of car that recognises a different person, not a person who has not existed before, but one we can understand better and take more seriously now we recognise them.

Innovation can unlock not only a new way of doing things, but more importantly, a new customer, a shift in what we value and take seriously. With that shift comes a change of focus, which gets more and more advanced until the next innovation and identity coincide and we move on another step, linking our understanding of people and what they do and matching it to the reality of what we can achieve at any one time. As one moves forward, the other comes too. Design and engineering, as the coordinators of the soft and hard, drive the car, not the other way round.

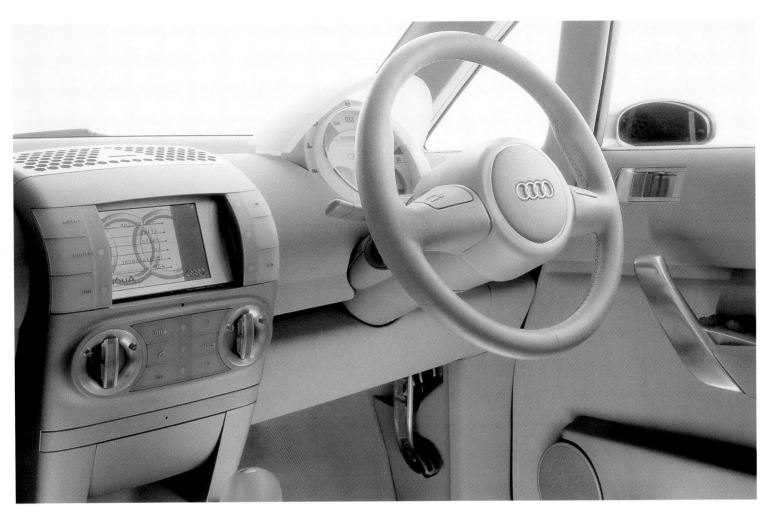

Aluminium, rather than conventional steel, affects every aspect of the shape of the A2. The form and detail exploit the material's different characteristics of bending and forming, allowing tight creases and sophisticated curves. The Audi design philosophy is one of honesty and purity, and is applied across the whole range of cars, from the sporty TT to the urban functional A2. The uncompromising attitude has helped Audi move from a conventional and unexciting brand in the 1970s to become one of the most recognised and aspired-to car brands in the world.

Understanding the future is one of the most valuable things design can do for us. In the balance of our everyday lives, we have little time to think of what might be. No crystal ball is required, just imagination and an understanding of what we would like to do given the choice. Design can create that vision, model it and allow us to experience the future, to analyse it and decide whether we like it. This is not science fiction, it's experience prototyping, taking a look at what we might want to do and helping us take control of our future, rather than being slaves of technology and science.

Hori

zons

ePen
Design: Cambridge Consultants
Research and Development Consultancy
Design: Sameer Shirgaonkar,
John Hogarth, Donna Wilson

## ePen – finding the killer application

We are constantly looking for a crystal ball, to look ahead at social behaviour and understand better what we will need so we can develop the right technologies, products and services. Technologies are created, often with little understanding of the ultimate goals, and delivered without consideration or understanding for how we might use them.

Designers can contemplate what might be. They may have intuitive understanding of our emotions and how we relate to the objects, tools and technology around us. Designers, therefore, can do better than a crystal ball. Rather than wait for the future, they can help define it, with a mixture of vision, humanity and pragmatism.

ePen was created by Cambridge Consultants, an organisation concerned with research and development of products and technologies from their conception to reality. Taking the Bluetooth wireless technology, which lets electronic products speak to each other without cables and connectors, the ePen shows us not what the technology is, but what value to us it might be. Increasingly, the applications of technology, and the methods of their delivery, are seen as crucial to the success or failure of new ideas.

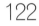

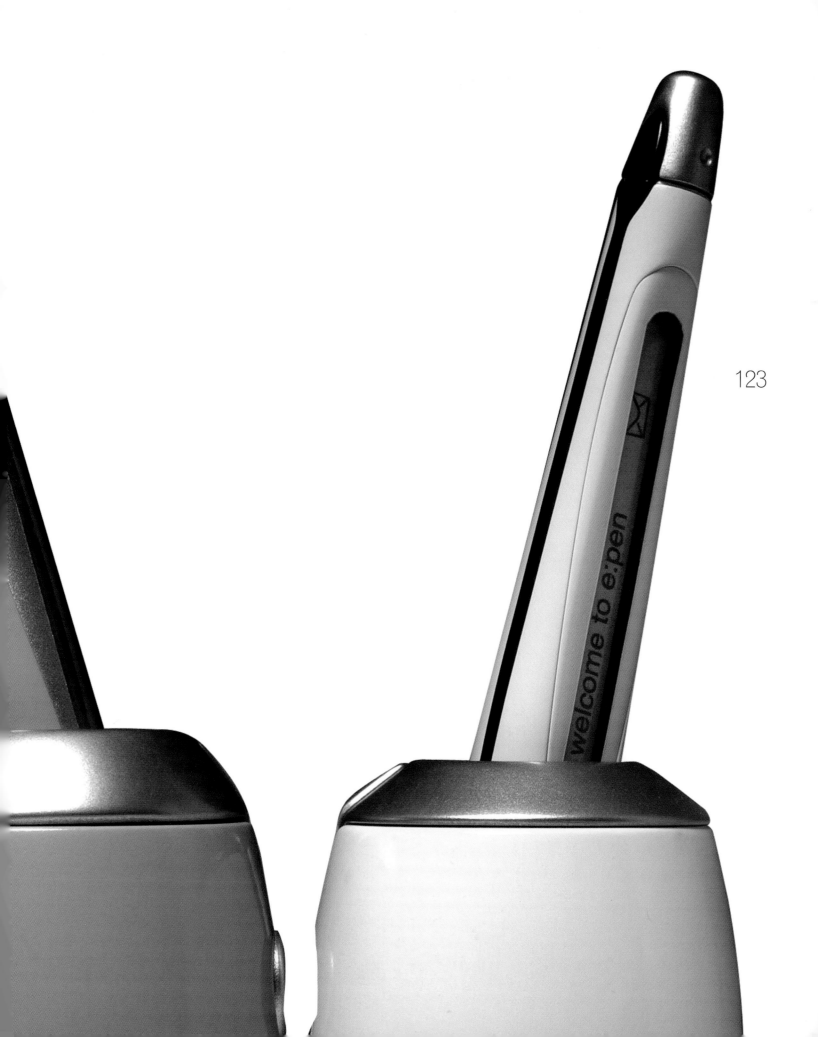

The design team focused on the metaphor of quill and inkwell for the concept of the ePen. We think we have advanced by moving from pen to **QWERTY** keyboard, because of the increased flexibility that comes from benefits of word processing, email and others. **But the method of interaction is worse than what it replaced; the technological solution is not as good as before. This design** is retaining all the benefits we have gained along the way, but reconfiguring technology back to the point where we started, to behave in a more intuitive and expressive manner.

124

ePen is a tool for generating emails. We are most used to email delivered via a PC, a large, expensive and wasteful mass of keyboard, screen, and electronics. ePen allows you to send and receive emails without a PC. By translating your handwritten movements into digital information and transmitting via the Bluetooth link to a base station connected to GSM or cable line, it reduces the size of components and creates a nostalgic, non-technological solution – a pen and inkwell.

Bluetooth has been created by a consortium of companies led by telecom manufacturer Ericsson to free technology from the cables and connectors that are different in every application. Bluetooth solves this by using radio waves to communicate across distances of up to ten metres, removing most cable requirements apart from power supply. Where power is in a battery, there need be no cable at all.

'Just being the first with new technology is a very momentary advantage. It's finding what people want to do with it, the "killer application", that's important.' For Donna Wilson and Smeer Shirgaonker, it's what you do with technology, not what it does, that counts.

They embarked on a project to define three things: what were the benefits the technology could bring, how would that affect the products we use, and what would those products be like to use? To start with they considered the advantages that Bluetooth products have over existing ones. Bluetooth needs less power, is smaller and provides freedom of movement. So what does that look like in a real product? ePen came from a brainstorming of how things could be different. By linking it to email, the Cambridge team could show a real application that made a current cumbersome and wasteful process become a personal, convenient and enjoyable act.

Rather than conform to the tyranny of buttons and circuit boards, ePen makes the electronics work for you, and in doing so makes an object charming, of value and meaning to us. 'Technology should be hidden,' says Sameer. 'It's not about creating a wow factor for the technology, it's simply about no wires, freedom of movement, and doing what you want in a way that suits you.'

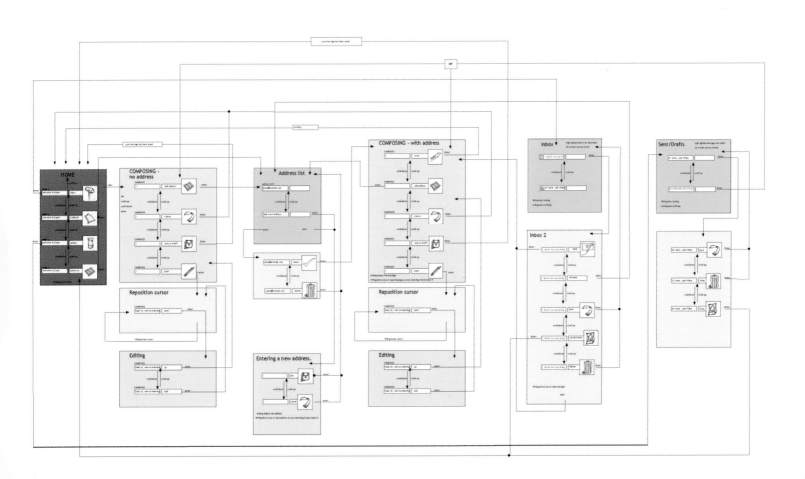

### Driving technology from the heart

One of the most powerful aspects of design is the ability to visualise, understand and experience what the future might be. At its most powerful, visionary conceptual design, built around real human behaviour, emotions and needs, can focus and generate new technologies and innovations, all the more enduring for being based on what we want, rather than what can be done.

Technology with design at its core, concerned with how we understand and use new life tools, can reduce the type of technophobia that slows down our acceptance of new technology. 'I assume that everyone is technophobic,' says Jonathan Ive of Apple Computer. Often, the take-up of technological products is held back by social reluctance to change ourselves rather than the technology. And even now, from the video recorder to the microwave and the WAP Internet-connected mobile phone, poor design of the hardware and software leads to frustration and ultimately rejection.

Designers, as a result, have begun to look for more natural and understandable metaphors when designing products where technology means they need have no shape at all. They are concerned how products behave, feel and communicate with you and often refer to a pre-electronic age where mechanics and engineering, rather than technology, defined the shape of products.

What we think of as the natural way of using things is often based on their original industrial processes – and often new technology retains that original non-electronic form, as the first cars retained the appearance of horse-drawn carriages. Designers have turned again to exploring what the natural, pure, intuitive ways of receiving information might be, now that pages of paper are replaced by parcels of scrolled text.

The ePen is such an exploration. Coming from an institution primarily focused on the creation and application of technologies, research and development organisations are understanding that the human aspect of technology can be the overriding factor in the speed of acceptance and understanding of new ideas.

126

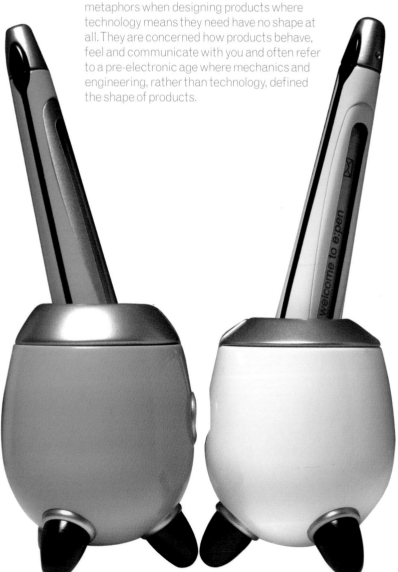

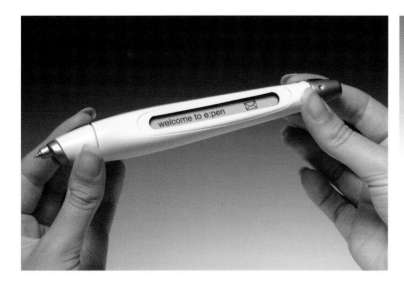

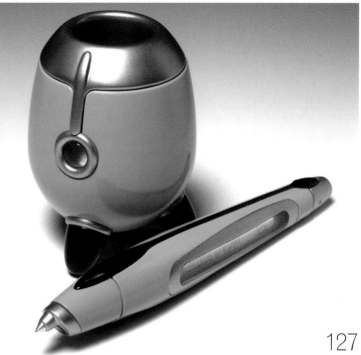

With the e-mate you write with a pen, not a keyboard, and when you are finished you return it to an inkwell. You write on any surface, the movement of the nib translated to data and to text characters. The inkwell houses the electronics to connect to a cell or land phone line, and recharges the batteries of the pen. To see what you have written, the text is displayed in a window along the pen, which scrolls along as your message is created.

127

**Receive e:mail**

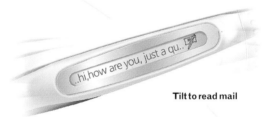

**Tilt to read mail**

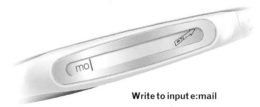

**Write to input e:mail**

Reading what you have written, or what others have sent you, is done in the same way. The text flows left or right by tipping the pen to either side.

**Send your e:mail**

# New Domestic Cooking Tools
## Matsushita Electrical Industrial
Design: IDEO and Matsushita Electrical
Industrial Design Team

## Designing for experience

Matsushita, known as Panasonic around the world, set up a workshop in association with design company IDEO to design a set of breakfast tools. They designed a number of products around the theme of breakfast which covered both Japanese and Western practices and included a coffee maker, toaster, egg steamer, thermos drink holder, rice cooker and juicer.

Each product is an exercise in restraint, the simplest and purest of forms – white plastic combined with frosted or clear glass. In each one is a simple idea that extends the function one stage further to become part of the whole breakfast. The lid of the toaster is removed to create a toast rack. The juicer sits on top of the glass and drops the juice into it. The top of the egg steamer becomes the egg cup from which it is eaten. Each idea creates surprise and delight.

**Yukihiro Tsuda's coffee machine shows the coffee is filtered through the transparent sides.**

Behind the Matsushita products is a radical way of designing. Creating design workshops is a way of combining creative thought, from designer and non-designer, and challenging the preconceptions of designers and companies alike. In this case, IDEO and Matsushita looked at everything to do with breakfasts to create a 'mind map', listing as many words that are associated with breakfast as possible. Each designer lived imaginary scenarios around people having breakfast to get under the skin and discover what people might do or need.

This sort of activity is not scientific market research or observational ergonomics. But it is extremely good at making people change their understanding of how people think. In IDEO co-founder Bill Moggridge's words, it is 'experience prototyping', where you can build a scenario and 'live' it yourself by a process of story-telling or enactment. So in this case the designers went through scenarios that included all aspects of breakfast activity from cutting bread, reading newspapers, pulling curtains or making coffee (or miso soup in Japan).

The aim of the project was to explore a more meaningful way of designing products and move away from reactive response to competitors to a more strategic position, where what products do is more important than what they look like. In every case the designers were looking to find a natural logic that linked the way the product worked to what it did. So the juice drops directly into the glass and the lid of the rice cooker could be used to clean the rice.

**Kazuya Takahashi's juicer sits elegantly on top of the glass. It's a minimal and entirely appropriate design solution that is difficult to improve. There is no styling but there is a very strong statement of functionality and experience that is striking.**

**Sam Hecht's toaster (right) has a lid with vertical rods that create a toast rack. The rods fit into the slots of the toaster when it is placed on top as a lid.**

The ideas have a Zen-like simplicity. Naoto Fukasawa, director of IDEO in Japan and member of the design team, believes 'if the tool doesn't live in our actions, it won't make its way into our daily lives.' These products, by doubling their use and directness of action, extend the time we use them and become part of the experience of eating rather than just a bit of gadgetry. The ritual of preparing and eating food is a rich vein for design to mine, whether it is Alessi in Italy, Chinese food implements or Japanese sushi knives. Function and beauty combine effortlessly and we have no problem with that, whereas we treat beauty with suspicion in more prosaic tools for work or leisure.

Experience prototyping
Working in workshops encourages people to remove their everyday concerns and problems and allows them to think without constraint. Experience prototyping allows us to consider the reality of life, as it is and how it could be. It's something everyone can do – from understanding how your customer actually feels when they want to buy your product or service to what your call centre sounds like or how your web page works. Are things easy? Are they where you expect them to be? We don't have to ask, we can live it ourselves.

132

**Egg Boiler by Toru Abe places the egg over a steamer. The steamer is turned over, leaving the egg sitting in its cup ready to be eaten.**

かたゆで

半熟

National

133

**Takeshi Ishiguro's rice cooker has a lid that
doubles as a sieve in which to clean the rice.**

# Digital Convergence,
# Third Generation Phones
# Samsung Electronics

Samsung Design Director: KH Chung
Samsung Design Europe: Clive Goodwin,
Mark Delaney

## A digital future

All around the globe companies are investing in digital technologies and the licenses to use them in an effort to survive the much-hyped digital revolution. Governments have auctioned slices of the airwaves to telecommunications companies who will compete to provide us with the Internet through the phone or digital TV and radio. But do we actually need these services? After spending such vast amounts on licenses, companies do not seem to have thought about what the customer will actually get, whether they even want it and, more importantly, whether they will pay for it.

Companies like Samsung may not be as well known as Sony or Philips, but their output, in the form of silicon chips, is firing the digital revolution and its associated phenomenon, convergence. Convergence is really about the coming together of what were traditionally separate products, industries or services into one. This occurs in the search for products and services that reflect what we would like to do, if we could. So with access to as many chips as they need, Samsung is in a good position to exploit convergence if they only knew what we wanted. They asked their design teams across the world to talk to people in research groups and understand what a digital future might mean. The designers then created the products that we would cross in all aspects of life.

Natural materials, pen shapes, and playful combinations of the qualities of diaries, address books and digital organisers, make each concept familiar and understandable. The design team are exploring how traditional forms reduce technophobia and draw technology back to a simpler, more usable form. Where many products have become metallic and sharp, the edges of these products have been softened and they have been camouflaged in leather and tortoiseshell.

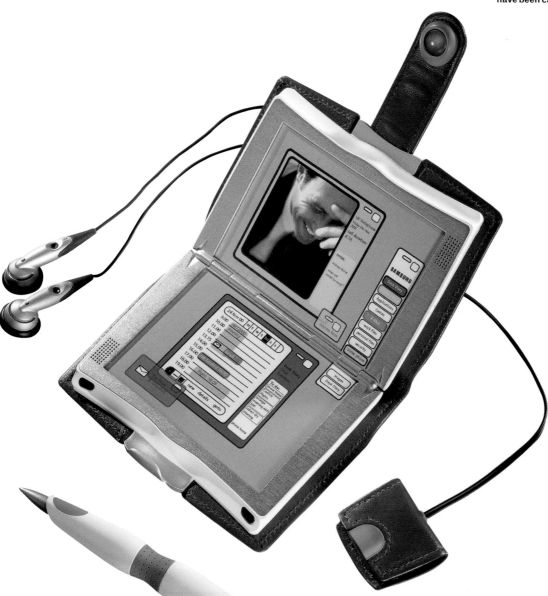

From the initial global research Samsung created a fictitious family of characters whom they could study in order to understand how they lived and what they did. This technique of role-playing or scenarios is one of the most successful tools designers have in their repertoire. It allows both designers, and non-designers to gain insight into how people think by taking on their character and role-playing their actions. Insight into all aspects of customer relations, from choosing the product to contacting the call centre can be predicted and understood. For the design process, scenarios allow designers to get under the skin of users, without the need to shadow them.

The Samsung family has a uniquely Korean feel as a US or European version would not reflect their culture. We can recognise many of the characteristics though, and learn what people might do. By looking at the work place and social and leisure activities Samsung began to map out how the technologies they provide might match the lives of their players. A system of products began to build up and by designing both hardware and user-interface together, they created a vision of future digital products and how they would be used.

Samsung, as do many companies, have always understood that cultures differ around the world. A network of design studios and design consultancies in Asia, the US and Europe work as tow-away conduits for analysis of cultural trends back to Korea and as instigators of products and design languages for their own regions. In London, the European design team took the core philosophy behind digital convergence and created a series of concept products around mobile phones.

The first generation of Internet-connected phones, WAP Wireless Application Protocol phones in the US and Europe, and Tech phones in Japan, have started the process of what looks likely to become total connectivity to the world through a device in your pocket. They are replacing PCs as the main portal to the Internet and other services. But for many, the foothills of a new technology are clumsy and slow, with hardware and software ill-suited to our need for fast, convenient and visible information. The next generation of phones promises to solve all of this, with instant connection and faster downloads, and larger screen areas to see what we need to.

For the Samsung design team it was important to give these products real humanity, doing what we want in a style that's personal, inviting and intuitive. Their solutions use metal, soft rubber and leather, and they open and fold, revealing hidden screens and softly formed buttons on every face.

The PDA Phone is just that: a Personal Digital Assistant and a phone in one. The telecom industry calls this a smart phone, a phone with a big screen, but this phone has three screens, to give you what you want to know where you can see it.

The second concept takes up the promise of full 3rd Generation (3G) connectivity to deliver video telephony, games and movies. The leather wallet opens to reveal a virtual desktop, a camera in the clasp allowing real time video link-up. The designers have used material and form to connect us to traditional objects to remind us of the value of the information they hold. Again, designers are seeking to connect us with technology in an emotional as well as functional way, and also make sure that the object follows our behaviour rather than changes it.

Personality and possession –
the real values of technology
Samsung shows a concern for cultural differences and a desire to understand us better. It's a worthy humility that understands we are all different and can take opportunity from that difference rather than blending us into conformity. Technology should and will, ultimately, allow each of us to be completely different should we wish to, though in this age of transition we are homogenised by technology, forced to find power button and keypad, at the tyranny of the menu, unable to decipher or understand.

Almost unbelievable technology will be here soon and these products show designers grappling with how we might wish to use it. The emphasis on material quality, softness of touch, microscopic attention to detail and beauty in form reveals how important the physical will be in delivering the virtual. For these products will be our wallets, our diaries, our connections to our loved ones and our professional network. Physical reality is even more important when all our belongings are thoughts, virtual, in the ether.

138

**With Walkman-like earphones this could be an MP3 player but it's actually a communication device, using Bluetooth to connect cordlessly. A small screen with buttons clips to your shirt collar to allow you to see what you have told the phone to do, and turn it on and off. The main device can be used as a phone, but turns into a full PDA with Internet access when folded open.**

Macrowave Project
Whirlpool

Design: James Irvine, Konstantine Grcic,
Christophe Pillet, Riccardo Giovanetti,
Jacco Bregonje, Björn Goransson,
Mario Fioretti, Mark Baldwin
Design Director: Richard Eisermann

# New frontiers for the modern microwave

A microwave is not an object to get excited about. It's a useful cooking tool, an uncomfortable compromise between being big enough to get a decent-sized plate in and small enough to fit on the kitchen top or be built in over the cooker. They are generally white, with curvy fronts and a complex control panel that claims to cook everything.

Whirlpool is the only major manufacturer of microwaves outside Asia. They know that they have to work harder than anyone to understand what their products should be. To help them do so, they embarked on a remarkable project to work with a team of designers, from both outside and inside their organisation, to explore what a microwave could be.

The microwave was invented by accident just after the Second World War when an American scientist, Percy Spencer, noticed that a chocolate bar had melted in his pocket when he was testing a high frequency emitter called a magnetron. The modern microwave is not much more than a magnetron and a timer, which turns it intermittently on and off. Both are placed in a protective case so we don't get cooked too. The first products were seen as replacements for the cooker and it wasn't until the late 1960s when cheaper counter-top products were developed that they took off. Little has really changed since then but design has become key to what is now a huge global market.

As project manager Jacco Bregonje explains, 'not believing that as an individual designer I am able to predict the future, I wanted to organise a workshop with a team of designers to experience different options.' By creating such a workshop, Whirlpool were able to harness the creativity of eight designers, all of whom could work with each other to create a diverse range of potential future products. Working with four internationally renowned designers from a range of backgrounds, and also with four Whirlpool designers, from Europe, the US and Scandinavia, meant that the experience would be retained and then disseminated throughout the company.

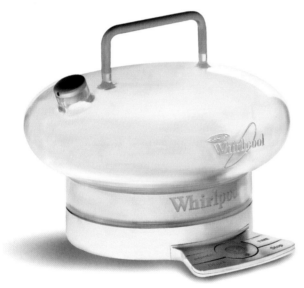

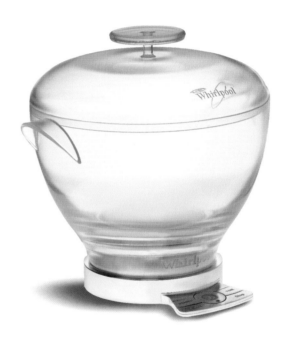

**Christophe Pillet is a French designer who now works in Milan after spending five years with Philippe Starck in Paris. His concept 'Pots and Pans' is perhaps the purest and most startling of the designs – a series of glass vessels, some which suspend the food in a metal basket. The vessels have a utilitarian beauty from the textured glass that gives them naturalness, as if they have evolved from traditional cooking pots. Their character emphasises the freshness and cleanliness of the microwave cooking method. The remote control, worn around the neck, means you can move around the house and stay conscious of the cooking time.**

'Chef' is by Konstantin Grcic, a designer famous for his work in Italy and Great Britain in furniture, lighting and products. For Grcic, 'food is culture', a source of great pleasure, even a treat. Microwaves are about speed and practicality with little of the enjoyable experience of cooking. 'Chef' is a radical redefinition of the microwave as cooking ritual. 'Why are they rectangular,' he asks, 'when plates are circular? Looking into a microwave is a strange experience; food should be viewed from the top, with smells and steam to show it is cooking.' 'Chef' puts the magnetron into a countertop hob. Place the dish on the hob and cover with the relevant steel cover to allow the cooking to start. It's an ingenious reversal of the engineering in order to return the sense and joy of cooking.

James Irvine is a British designer working in Milan. He is well known for his work with Olivetti and with some of Italy's most famous furniture companies. 'Sound Wave' is treated as a graphic icon of a microwave, to enhance recognition and a feeling of safety. The door slides down to protect us from the waves, and a FM radio is built in, as a celebration of where gadgetry and needs collide. Its softly rounded form and stainless-steel appearance deliberately combine aspects of radio, cooker, and other electronic products. It is an intriguing and stylish object that is friendly and easy to interact with.

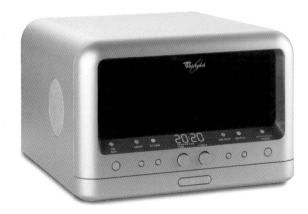

Jacco Bregonje is the in-house designer who came up with the idea to have a team of outside and in-house designers work together on ideas for future microwaves. His own concept 'Picard' is a countertop product with the freedom to be moved anywhere in the kitchen. 'Picard' splits the product into two, with the chamber only added when cooking is required, as in Grcic's 'Chef' concept. The plates of the microwave is also a weighing scale to allow the microwave to work out how much cooking time is needed.

Riccardo Giovanetti is an Italian furniture designer. His 'P.I.C.N.I.C.' concept is about mobility and cooking anywhere you want. His microwave looks like a bag for eggs and bread, with elegant handles concealed in the rim and a ceramic form and colour. Giovanetti wants the products to have the precision and tactile control of a piece of hi-fi rather than the clumsiness of a slammed door.

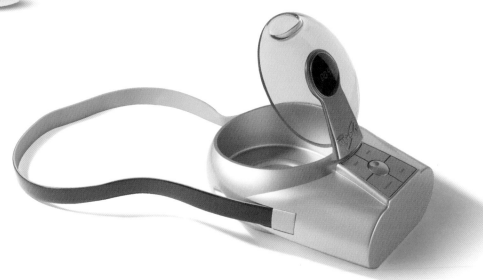

Mario Fioretti is from Brazil and his 'Micro Top' project focuses on young people who are more frequent users of microwaves as providers of fast and convenient cooking. The concept creates a portable cooking source for outdoor activities and is aimed at a wide range of users who want to cook on the move, from truck drivers to office workers. The witty similarity to a portable **CD** player makes it an object of fashion and youth, a complete departure into an entirely new type of use.

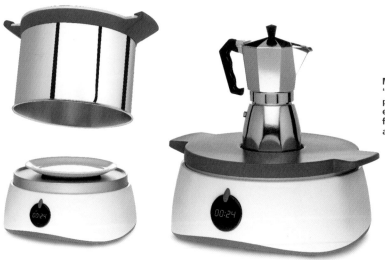

Mark Baldwin is a Whirlpool designer in the **USA**. His 'Vertigo' places the microwave on the floor. It then provides storage for plates, food and a fuel-cell electricity generator which stores the energy required for cooking. The fuel cell is recharged by simply adding water.

Christophe Pillet recreates 'l'art culture' in his glass containers which sit over the magnetron and use wire cages to contain vegetables. Pillet also creates a pendant remote control, recognising the many different jobs that take place as food is prepared around the kitchen. Riccardo Giovanetti moves the microwave out of the kitchen completely to anywhere in the house or patio. The only limit to cooking for him is the position of a power socket, so his designs look like food baskets with handles, the simplest of controls and a tray for glasses at the same time.

Jacco Bregonje creates a countertop cooking station; Björn Goransson merges the microwave with grills and a refrigerator to create a total cooking experience trolley, to be moved where you need it. Mario Fioretti creates a backpack Walkman-style microwave and Mark Baldwin turns it into a floor-standing piece of food-storage furniture.

As Design Director Richard Eisermann says, 'These proposals are more than designs, they are stories.' It would be easy to criticise any of these designs and challenge their technical feasibility. But that would miss the point. By removing the barriers and working together, the designers have explored the outer limits of what something as mundane as a microwave could be. They have rediscovered along the way how much we relish and enjoy the culturally defining act of cooking and the strong relationship between how we cook and the implements we use. These designers have tried to rekindle long-held traditions in cooking with advanced technology to create things of greater meaning and relevance.

## Visions and pragmatism

These eight examples are surprising and engaging. Most would not believe how different from our preconceptions a microwave could be. But what is the chance of these becoming real? And which of these should they go for?

The answer is that probably none of them will be made, but their influence will be great. Showing them to customers and the public will unlock opinion and emotion that would never be found in conventional market research. As car companies do with concept cars, new ideas can be tested and the reaction of customers learned. For the designers many things will have been learned in this workshop in considering aspects of use, new materials and formats that would never be considered in the day to day job of developing real products for manufacture. By investing in the exploration of the emotional as well as the functional requirements of the cooking experience, they will be able to identify what we want our products to do and how we want them to fit into our lives. These values are the ones we make our decisions on, in a world that works and is safe but has little value or pleasure. Especially in a microwave.

147

**Björn Goransson is a Whirlpool designer from Sweden. His 'Trollo' project creates a trolley countertop, incorporating everything needed for food preparation, including a refrigerator. Goransson wanted to change the perception of the microwave as an object just for defrosting or re-heating food, and create a real cooking product. To do this he incorporates other technologies such as halogen hobs and the refrigerator to store ingredients in close proximity.**

24/7 Concept Vehicle
Ford Motor Company
Project Designer:
Laurens van den Acker

## Multi-interactive tools for navigating through time and place

The car is the object that defines mankind in the 20th and 21st centuries. Our most expensive possession after our homes, a mass of sophisticated electronics, metallurgy and mass-manufacture, it is the vehicle for our vanity as much as transportation. Broadcasting all our aspirations and perceived status and removing our inhibitions through design it is on the one hand cutting-edge and the other nostalgic.

Starting as the horseless carriage, the form of automobiles has changed very little. On the inside, we still prefer dials and buttons reminiscent of Second World War fighter planes. As Ford's Laurens van den Acker puts it 'our cars are like old typewriters; every letter has an associated mechanical key – one action only, inflexible, impersonal.'

24/7 is an attempt to move cars from the industrial age to the information age. It takes the communication tools of mobile phones, the Internet and GPS satellite navigation and blends them with interaction technology of voice recognition, cameras and flat screens to create a vehicle that recognises and changes in personality to suit different drivers and different situations. It's a car to navigate through time as well as place. As Ford boss Jac Nasser puts it 'One hundred years ago Henry Ford put the world on wheels. Today Ford will put the Internet on wheels.'

24/7 has two distinct aspects. On the outside, it's a diagram of a car, a strict geometric treatment that tells you this is not about styling in the conventional sense, but a conveyor of a big idea. J. Mays, Vice President of Design at Ford, asked the designers to say something different in 24/7 and from the first pages of the design team's diary we can see how the exterior of the car is treated. It is a graphic canvas that places the emphasis on what the car does and how it behaves rather than its shape.

The three forms, saloon, station wagon and pick-up, reflect traditional American car formats but it is there that the similarity stops. 'The outside is direct and to the point – functional and trustworthy, ready to work straight away. Cars are so often soft on the outside and hard on the inside. We wanted it the other way round,' says van den Acker. Its boxy shape and precise machined lines are unpunctured by lights or air intakes. Translucent surfaces hide lights and logos, which suddenly appear through the skin.

Windows tessellate down and up as if designed on a Game Boy, sometimes showing right through the car. The interior explodes out from swinging 'suicide' doors that open out like windows to show a soft, space-frame-like, multi-functional interior.

Inside the 24/7 you enter a world where both shape and control is soft and virtual. Hovering behind the steering wheel floats not a traditional hard surface of dials and buttons but a projected screen allowing for just as little or as much control as you wish. Speak to the car and it knows who you are, finds your music in every format from radio to MP3, your email and websites you and your passengers might need to find out what you want, where you go to find it and of course how to get there.

If you are meeting friends for lunch, you can call them on the hands-free phone to agree the venue, email them the directions, and let the GPS system guide them there. Point the camera out the rear-view mirror to film the view and email it your grandparents. The new VW Beetle might have a vase for a flower and many cars offer navigation screens but this software lets you have a full bunch and not have to water them. 'Some might just want a picture of flowers and the kids. They'll want the GPS navigation when they get lost, but why should we have to look at it all the time, especially when it's stuck down round our knees?'

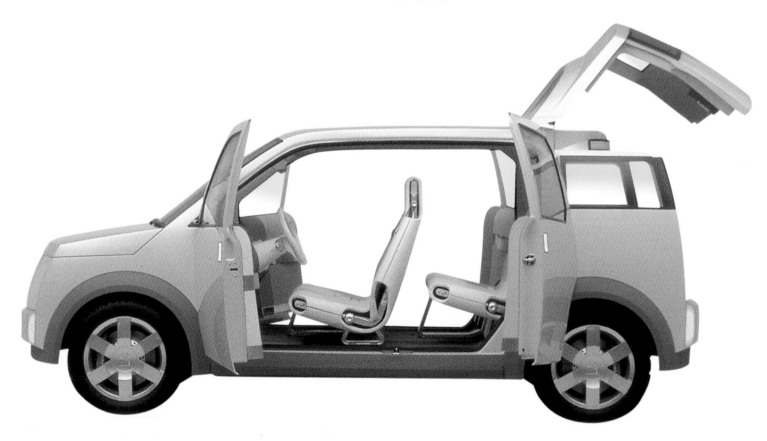

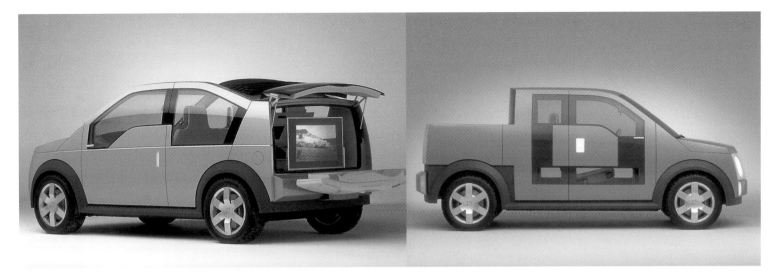

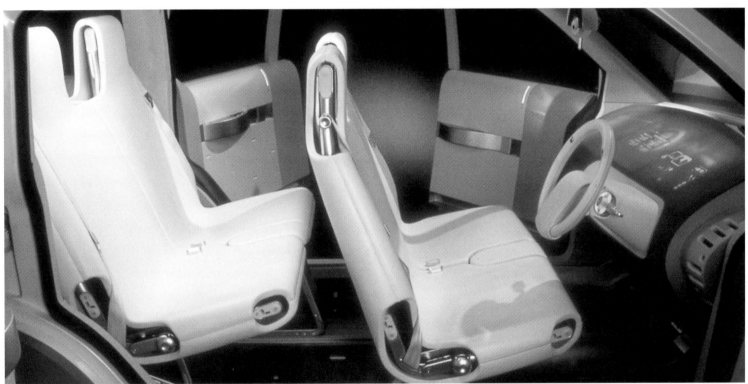

The exterior of the car explores three functional forms of vehicle: saloon, estate, station wagon, and pick-up. The real innovation is on the inside, where the projected dashboard allows for complete personalisation of dials, ergonomics, music, navigation and every aspect of use. In a series of scenarios developed by Ford, the potential of the 24/7 is explored with different people's lives showing how they might benefit form the combination of technology, connection and personalisation. It's this that makes the 24/7 interesting and unique in a world where concept cars are rarely more than shapes to drive fashion and test dealer reactions.

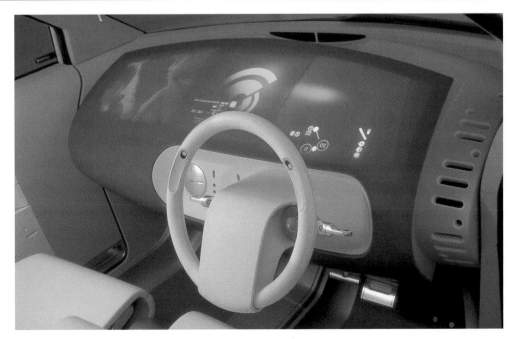

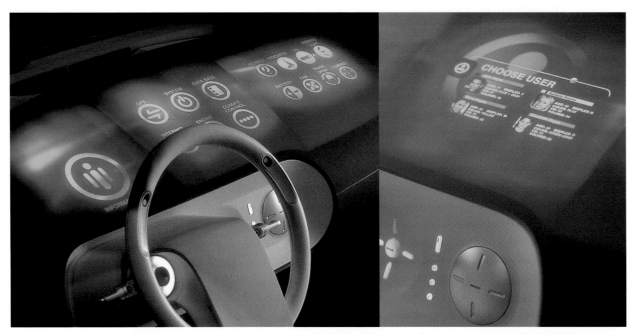
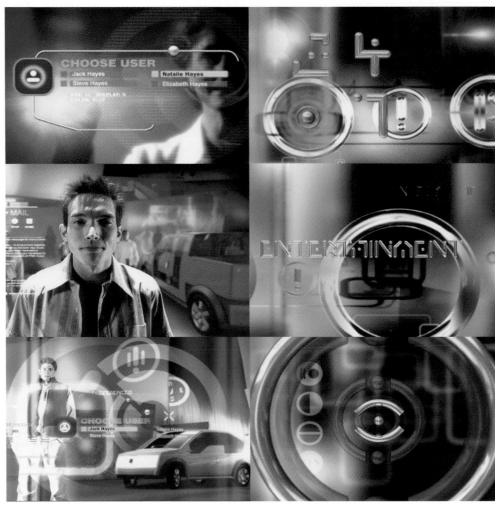

With a 'soft' interior, the car becomes a real-life tool, giving us what we want, when we need it. You can't normally change the colour of a car dashboard but with projection you have whatever you want, reflecting the personality of each family member. A car might be for work, for school, for going to friends, for holidays and trips, for people, for stuff. 24/7 is not just about changing the seat covers; it's about changing the whole function and character of the vehicle to suit the person and what they do.

'We wanted to please grandmothers, not technophiles,' says van den Acker. 'Technology is often too specific in its design, asking us to dial a number, when what we really should say is "call Mum".' Taking this philosophy through every physical and graphic aspect of the vehicle, the accelerator and brake pedals are identified as plus and minus. 'It's about reducing everything down to basics, and finding not what we can do, but what we want to do.'

24/7 taps into a social desire to communicate and personalise. This desire affects many aspects of life but it has yet to be seen in traditional, standardised, industrially based automobiles. As J. Mays says, '24/7 is not just about transportation; it's about guiding you through life.'

(left) The merging of 2D and 3D is a constant theme of the car, from the graphical outside to the three dimensionality of the screen images. Developed by design group The Attik, Simon Dixon explains, 'the images had to be immediately understandable. Different activities could have different graphical personality, and we tried to create a sense of depth and meaning in what is just a surface.' Even the tyre-tread is digital, the idea taken from a US digital postmark.

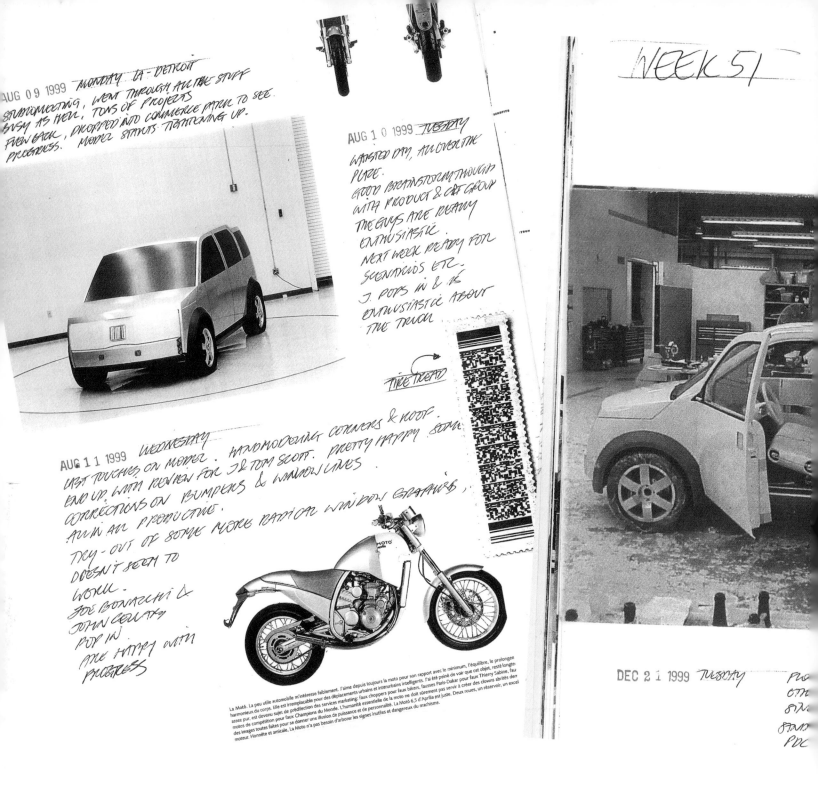

AUG 09 1999 MONDAY LA - DETROIT
STUDIO MEETING, WENT THROUGH ALL THE STUFF
BUSY AS HELL, TONS OF PROJECTS
EVEN GACK, DROPPED INTO COMMERCE PARK TO SEE
PROGRESS. MODEL STATUS TIGHTENING UP.

AUG 10 1999 TUESDAY
WASTED DAY, ALL OVER THE
PLACE.
GOOD BRAINSTORM THOUGH
WITH PRODUCT & CAT GROUP
THE GUYS ARE REALLY
ENTHUSIASTIC
NEXT WEEK READY FOR
SCENARIOS ETC.
J. POPS IN & IS
ENTHUSIASTIC ABOUT
THE TRUCK

TIRE TREAD

AUG 11 1999 WEDNESDAY
LAST TOUCHES ON MODEL. HANDMODELING CORNERS & ROOF.
END UP WITH REVIEW FOR J & TOM SCOTT. PRETTY HAPPY. SOME
CORRECTIONS ON BUMPERS & WINDOW LINES
ALL IN ALL PRODUCTIVE.
TRY-OUT OF SOME MORE RADICAL WINDOW GRAPHICS,
DOESN'T SEEM TO
WORK.
JOE BONACCHI &
JOHN COLLTRY
POP IN
ARE HAPPY WITH
PROGRESS

La Moto. La peu utile automobile m'intéresse faiblement. J'aime depuis toujours la moto pour son rapport avec le minimum, l'équilibre, le prolongement harmonieux du corps. Elle est irremplaçable pour des déplacements urbains et interurbains intelligents. J'ai été peiné de voir que cet objet, resté longtemps assez pur, est devenu sujet de prédilection des services marketing; faux choppers pour faux bikers, fausses Paris-Dakar pour faux Thierry Sabine, faux motos de compétition pour faux Champions du Monde. L'humanité essentielle de la moto ne doit sûrement pas servir à créer des clowns abrités derrière des images toutes faites pour se donner une illusion de puissance et de personnalité. La Moto 6,5 d'Aprilia est juste. Deux roues, un réservoir, un excellent moteur. Honnête et amicale, La Moto n'a pas besoin d'arborer les signes inutiles et dangereux du machisme.

DEC 21 1999 TUESDAY

**In a series of design diaries, Laurens van den Acker chronicled the development of the 24/7 from initial diagrams of how the use of the car changes through the day, and over the week, through sketch, computer and modelling of the outside shape and interior concept. The single vision, of a multifunctional, internet-connected vehicle, meant that interaction, usability, product and automotive design work together.**

Converging technologies, diverse behaviour
It's difficult to break down barriers, even in the most advanced technologies. A cell phone still looks like a phone, even though it might be an Internet browser. A car that contains such sophistication under the skin still has static and inflexible control systems that little reflect the many different uses a car has.

Convergent technology means bringing different aspects of technology together to match what we actually do. The traditions

FINISHED RUBDOWNS, GOT THEM ORGANIZED
THROUGH LETTERGRAPHICS & AARON
WATSON'S PAINTED, SANDING & RUBBING
IT DOWN.
DECIDE ON INTERIOR COLOR BREAKUPS
HAVE AARON DO COLOR RENDERING &
BRING IT TO SPK

DEC 22 1999 WEDNESDAY
7AM WONDERFUL DAY. ALL OF A SUDDEN EVERYTHING STARTS UP
& THEY'RE PUTTING TOGETHER WHEELS, TIRES, INTERIOR
PANELS, HEADLINER EVERYTHING.
ALSO BEAU & SIMON ARE THERE TO INSTALL IP PROPOSAL
LOOKS GREAT. OTHERWISE FANTASTIC DAY. NOTHING LIKE SEEING A
CAR COME TOGETHER. LEAVE AT 3AM IN HIGH SPIRITS

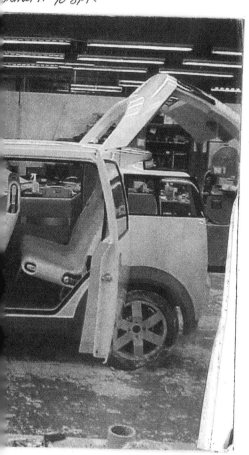

TS ARRIVE
A SEEMINGLY SLOW DAY,
EVERYBODY'S PAINTING &
DAY.
...LESS SEEMS SLOW TOO.

of different industries still blinker vision. 24/7 brings technology together and looks for the functional and emotional benefits to be gained, free of the preconceptions of tradition.

Suddenly the car, which takes us on holiday, can send the postcard, help us return, look ahead for danger, and provide whatever ambient environment we wish. Slowly, the car moves from the age of industry to the age of information, from hard to soft, from action to experience, from today to tomorrow. 24/7

represents a giant leap in our thinking about private transport and moves the emphasis from the outside of the car to what's under the skin. 24/7 is a design vision, a living crystal ball, that allows us to look over the hill and see a bigger horizon, where technologies come together to enable us to do what we need to. The industry may have laughed at the 'Internet box on wheels', but as J. Mays has said 'design is more than folding sheet metal'. The 24/7 could be as influential as the Model T.

# Designers
# Biographies

Astro
41 Valencia Street
San Francisoo
CA 94103
USA

Apple Computer
20730 Valley Green Road
Cupertino
CA 95014
USA

Bang & Olufsen a/s
Peter Bangs Vej 15
DK-7600 Struer
Denmark

Black and Decker
Julian Brown
6 Princes Buildings
Bath
Avon
UK

Cambridge Consultants Limited
Science Park
Milton Road
Cambridge CB4 0DW
Cambs
UK

Hollington Associates
1 Alfred Mews
London W1T 7AA
UK

IDEO
White Bear Yard
144A Clerkenwell Road
London
UK

IDEO
700 High Street
Palo Alto
CA 94301
USA

Kinneir Duffort
5 Host Street
Bristol BS1 5BU
UK

Nokia Design Centre
Nokia House, Summit Avenue,
Farnborough
Hampshire GU15 0NG
UK

Philips Design
Building HWD-4
P.O. Box 218
5600 MD Eindhoven
The Netherlands

Porsche Design GmbH
Flugplatzstr. 29- A5700
Zell Am See
Austria

Samsung Design UK
Samsung Korea

Seymour Powell
The Chapel
Archel Road
London W14 9QH
UK

Sony Corporation
6-7-35 Kitashinagawa
Shinagawa-ku
Tokyo
Japan

Sony Europe GmbH
Design Center Europe
Kemperplatz 1
10785 Berlin
Germany

Tangerine
8 Baden Place
London SE1 1YW
UK

TKO
37 Stukely Street
London
WC2B 5LT

Whirlpool Europe
Divisione Commerciale Italia
Viale G. Borghi 27
21025 Comerio (Va)
Italy

# Final Word

The examples of design in this book tell the stories behind great products and the people who set out to challenge and improve the objects around us.

The interaction between designers and organisations is central to the way in which the world is designed. Great individual vision and the desire to design things better can be found in all people, whether designers or not. The ability of designers to visualise, test and create products that exceed our expectation depends very much on the culture they work in and the attitudes of those they work with. Design is not just about the individual designer; it's about a whole compilation of aims and events, people and processes.

Whether we are designers or consumers, organisations or individuals we all have a hand in creating a better-designed world. At a time when the methods of product manufacture, who makes them and what happens to them after use is increasingly important, our collective ability to push for the right kind of design is stronger than ever.

We need never put up with mediocrity – we should demand the highest design quality for all and turn the world from one that is led by technology and materials to one that is user-led, of more value to all and that responds to all our needs.